WATERCOLOR
snacks

Inspiring Lessons for Sketching
and Painting Your Favorite Foods

Watercolor Snacks
Inspiring Lessons for Sketching and Painting Your Favorite Foods

Volta Voloshin-Smith
Colorsnack.com

Editor: Kelly Reed
Project manager: Lisa Brazieal
Marketing coordinator: Mercedes Murray
Copyeditor: Joan Dixon
Interior layout: Aren Straiger
Cover production: Aren Straiger
Cover Images: Volta Voloshin-Smith and Bri Crow Photography

ISBN: 978-1-68198-715-6
1st Edition (1st printing, July 2021)
© 2021 Volta Voloshin-Smith
All photographs © Volta Voloshin-Smith except author photo by Bri Crow Photography.

Rocky Nook Inc.
1010 B Street, Suite 350
San Rafael, CA 94901
USA

www.rockynook.com

Distributed in the UK and Europe by Publishers Group UK
Distributed in the U.S. and all other territories by Ingram Publisher Services

Library of Congress Control Number: 2020944252

To Dan, my husband,
who believed in my potential for being an artist before I did.

Table of Contents

Introduction

I never went to art school. My ignorance was bliss. I didn't know how many ways my art could go wrong so I was open to trying anything! In fact, I didn't expect myself to be any good at all, so my focus was to just try new things, experiment, and essentially play with colors. My intention is to encourage you to do the same: whether you're a beginner or a seasoned artist, I hope you find some useful and inspiring tips to get you creating on a consistent basis. And since food is such a huge part of our lives, there's always something inspiring and yummy to paint.

Watercolors are my favorite medium for several reasons. First, I find the way water interacts with pigment incredibly soothing. Second, you don't need a lot of setup time to begin working. Typically, you can get a beginner's palette that will come with a wide range of colors in it. So, the time from decision to action is minimized, which I feel is important. We all lead busy, hectic lives, so I encourage any little hack that can allow us to have a bit of creative fun during the day. Another reason I love watercolors is the ability to almost "erase" accidental marks from the paper. In the coming chapters, I'll share with you a few basic techniques that will make your watercolor paintings pop off the page.

I hope this book inspires you to keep exploring the wonderful world of watercolors with these simple techniques for painting foods. Since this book focuses more on painting than on learning how to draw, I've put together a bonus PDF that contains all the line drawings found in this book. If you're not a proficient drawer, I don't want that to stop you from experiencing the magic of watercolors! Feel free to trace the drawings with a pencil and then you can get to painting right away.

Recommended Supplies: The Ingredients

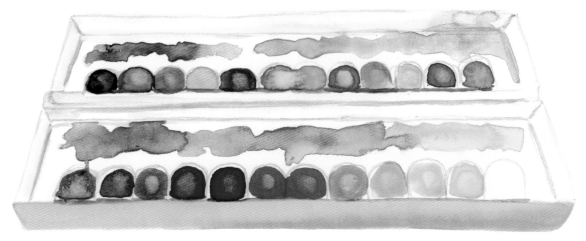

Paper

Paper is probably the single most important part of a joyful watercolor experience. Too often, I've bought cheaper paper and was disappointed because my watercolor paintings did not look the way I wanted them to. For this reason, I highly recommend investing in paper over other materials because the right paper will enhance your experience and will only add more joy to the process.

Typical watercolor paper comes in two types: cold press and hot press. Hot press has a very smooth surface, with almost no "tooth" (or texture). This paper will dry fairly fast. Cold press paper has a slightly textured surface and won't dry as fast because the paint will pool in the textured surface.

Watercolor paper also comes in various "weights" that essentially indicate how thick or thin a paper is. Watercolor paper is measured in pounds (lbs.) and typically

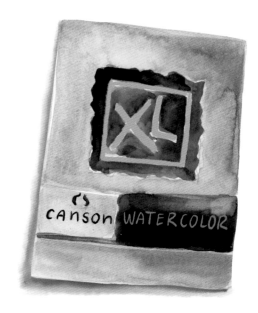

ranges from 90 to 300 lbs. The standard and most common weight you'll see is 140 lbs. Most papers that are less than 140 lbs will buckle when wet and may even tear, thus ruining the whole experience. (If you do end up using paper that is less than 140 lbs, for example 90 lbs, then be sure to be judicious with water usage). Even 140 lb paper can buckle a bit but it's manageable and given that we'll be working on food illustrations and not applying a lot of water onto the paper, you shouldn't need to stretch the paper. If you choose to stretch your paper, one common way of doing so is to use washi tape around the edges and attach it to a hard board. This will prevent some of the buckling that can occur.

My favorite brand of paper to use in my watercolor workshops, and even for client illustrations, is Cold Press Canson XL Watercolor Pads 140 lbs. A pad of this paper will have one of the edges glued together, which allows for easy tearing once you're done painting. This particular brand also comes in a large pad size of 18″×24″, which is what I buy because the price is better and it's easy to fold and tear the large sheets into smaller sized sheets (and tearing gives us those nice, deckled edges).

> **Tip:** *When I'm working on a painting, I like to finalize my pencil sketch on copy paper (or any paper just to practice on). I then use a lightbox (or my window) to trace the sketch onto my watercolor paper and then I get to painting. This allows me to work out the kinks in my design and do all the erasing on the copy paper instead of doing it on the watercolor paper. This way, I am less likely to damage the watercolor paper's surface if I end up changing my mind and doing a lot of erasing.*

Brushes

My most used and overall favorite brush for food paintings is a water brush pen. It's essentially a brush that holds water inside its barrel, which gets released when you squeeze the barrel. My reason for suggesting a water brush pen is so you can work on your food paintings while you're out brunching with your friends.

While there are many kinds and sizes and shapes of brush pens, I want to keep it simple for you and recommend the brush I use most often: the Pentel Aquash water brush pen.

Here are some of the reasons I prefer using a water brush pen to a traditional watercolor brush:

- It's great to travel with: you can even take it on the plane and do some watercolor paintings during a long, boring flight.
- It allows me to paint on location, so if I'm at a restaurant and I feel inspired, I can start painting right then and there.
- There is no worry about spilling a cup of water or working with muddy water.
- It is easy to refill.
- The bristles are firm and work great for lifting off a highlight.
- Compared to a traditional watercolor brush, it doesn't hold a lot of water in the bristles, which allows for more control. A traditional brush will typically absorb a lot more water and be harder to control when painting small details (especially when depicting food).

There are many other great brands of water brush pens out there. For the entirety of this book, I created all my paintings using a medium sized Pentel Aquash water brush pen. I love that thing and I actually have several loaded up with water so I can keep painting without interruption.

If, for some reason, you're not a fan of brush pens, another option of brushes I really like are the Princeton Heritage brushes in sizes 2, 6, and 8. Those will give you a nice range of sizes to use for adding details to the snack paintings.

Tips on using a Pentel Aquash Water Brush Pen:

- Squeeze the water brush pen's barrel and the water will be released.
- The harder you squeeze on the barrel the more water will be released.
- You can squeeze a few drops into your watercolor well and load up on color that way.
- Move the brush on your paper as you squeeze to prevent puddles from forming.
- Use a towel or washcloth to wipe off the color from the bristles.
- Squeeze a little bit of water from the water brush pen as you're cleaning off/wiping the bristles on the towel.
- You can fill up the brush with tap water from the faucet or by even squeezing on the container so it sucks water into it.
- It rarely happens, but if your water brush pen container gets paint inside, you can clean it with a cotton swab and some warm soapy water. Be sure to rinse it well.
- By adjusting the pressure of the brush pen on the paper, we can control how narrow or wide the brush mark will be, like in the illustration here.

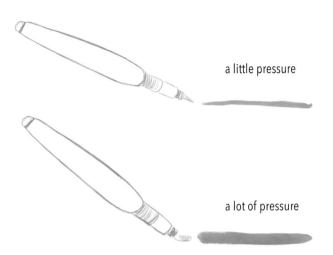

a little pressure

a lot of pressure

Watercolor Paints: Pans vs. Tubes

There are lots of amazing watercolor brands out there and I love many of them, but I want to share that you can create beautiful art even with the cheapest sets. Don't let the price point stop you from enjoying and exploring this medium.

When I first started with watercolors, I picked up the cheapest set I could find at a local craft store. What I want more than anything is to have a nice range of colors to play and experiment with. In each of the following chapters I will share the names of the exact colors I use, but even if you don't have that exact color, you can use an approximation from what's available to you.

With that said, some people wonder what's best to invest in: tubes or pans. I personally love the practicality of watercolor pans. They usually come in a nice compact palette, which you can open and start painting with right away. The watercolor tubes actually come in handy when I want to refill my pans: I just need to let those dry overnight so they don't overflow or mess up the palette. Some of my favorite watercolor brands are Daniel Smith, Schmincke, and QoR for professional sets. For more affordable options I like brands like Gansai Tambi and White Nights. I actually did this entire book's paintings using a White Nights palette.

> **TIP:** *I like having watercolor palettes that have large mixing areas. Sometimes though, the set may not come with a mixing area. One option is to use a porcelain plate for your mixing area. Another option is to use a plastic or metallic flat surface. In this case, you should cover the area with toothpaste (or something gritty) to sand away the surface a little prior to use. This will help to avoid beading of colors (where the color isn't spreading but instead is beading up and not letting you mix colors well). You may have to do this even on watercolor palettes that have large mixing areas before starting. The plastic typically will have a shiny coating and scuffing it a little with toothpaste helps break the surface tension and allows the paint to lay flat as opposed to beading up.*

Throughout the chapters, you'll notice I repeatedly use particular colors because they work well for food painting, therefore I recommend getting these exact same colors, as noted below. The rest can be found in a typical watercolor palette, and you can mix colors to create colors similar to the paintings in the book.

Recommended Watercolor Colors

As I mentioned before, don't let these specific color names stop you from painting and playing with watercolors. Typical watercolor palettes (even student/beginner grade) will have colors that are similar to the ones I use here. Below is a chart of all the colors I used to paint the illustrations in this book. Almost all of them came from the St. Petersburg White Nights 36 Pan Set set by Nevskaya Palitra. The few exceptions are Opera Pink and Payne's Gray, which I have by Daniel Smith brand.

If this list is too big for when you get started, I also specify which particular colors I highly recommend in order to get the intended results for painting the various foods.

I would say the four most important colors from my list for you to get are Yellow Ochre, Raw Sienna, Burnt Sienna, and Burnt Umber. These colors will be used often on foods that have a bread/dough component. The other colors are not as important to get exactly the same (either by name or brand) because you can find close approximations in many watercolor palettes.

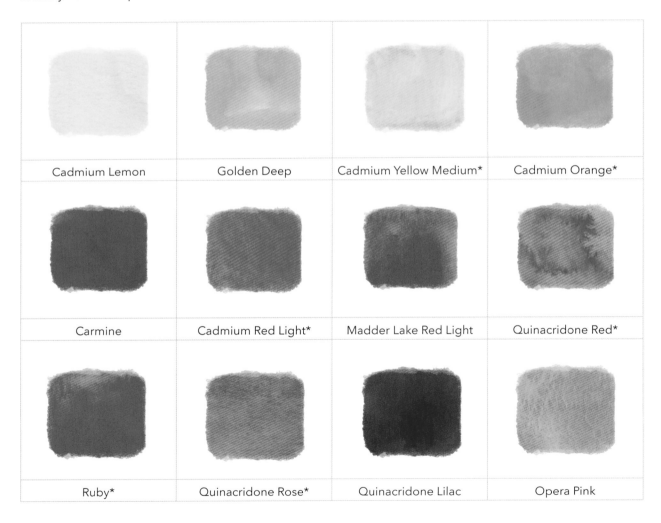

Cadmium Lemon	Golden Deep	Cadmium Yellow Medium*	Cadmium Orange*
Carmine	Cadmium Red Light*	Madder Lake Red Light	Quinacridone Red*
Ruby*	Quinacridone Rose*	Quinacridone Lilac	Opera Pink

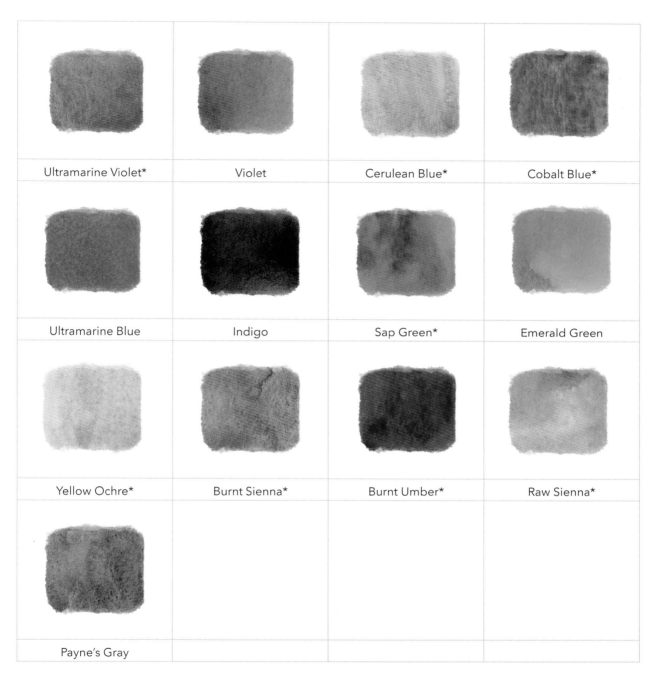

Ultramarine Violet*	Violet	Cerulean Blue*	Cobalt Blue*
Ultramarine Blue	Indigo	Sap Green*	Emerald Green
Yellow Ochre*	Burnt Sienna*	Burnt Umber*	Raw Sienna*
Payne's Gray			

*Highly recommended colors

Watercolor Sketchbooks

A huge part of my journey in rediscovering my inner artist was keeping a sketchbook. I loved having all my paintings in one place, and flipping through them takes me back to the moment when I sketched each one.

There are a few good brands of watercolor sketchbooks out there but it is most important to pay attention to the thickness of the paper. Not all sketchbooks are created equal and the ones you'll want to get are the ones that specifically mention *watercolor*.

> **Tip:** *If you want to start using a sketchbook for your art exploration but have a hard time starting it for fear of ruining the first page, I have a solution. I used to feel that fear all the time, thinking that my sketchbook art needed to be perfect or look a certain way. I started a small tradition of whenever I get a new sketchbook I would write on the first page "Blank Pages Are For Numpties" (numpty means foolish person in British English). Writing something totally silly like that on the very first page helped me get over the fear of perfection and I could just start using the sketchbook for what it was intended for: art experiments. I encourage you to take a similar approach and embrace all the side effects of experimentation with art.*

Paper Towels

Paper towels are your friends when creating watercolor paintings. First of all, they are great to use when you accidentally add too much water. Simply dabbing an edge of a paper towel onto that area will absorb the excess water.

Second, I often use a paper towel or a piece of cloth to wipe off my water brush pen. This will be essential if you are using a brush pen versus a traditional watercolor brush. Either way, I recommend having something to lightly wipe off any excess water when painting.

Pencil and Eraser

I almost always start my food art with a light pencil sketch (not applying a ton of pressure). My favorite type of pencil is a 2mm HB pencil by Staedtler. Because of its fairly soft lead, the pencil markings aren't as pronounced and sometimes can be erased even after a light layer of watercolor has been painted on top of it and it is completely dry. My favorite eraser is the Mono by Tombow. These are really great at erasing any tiny pencil marks without tearing your watercolor paper.

Hair Dryer

If you're painting at home and find yourself impatient about your watercolor layer drying before proceeding to the next step, I highly recommend using a hair dryer. Use it on a warm setting and gently go over the page until the whole area is dry. It's a great way to speed up the drying process.

Basic Watercolor Techniques

I want to share a few basic watercolor techniques that I love to teach in my workshops. Even though we won't necessarily be using all of them to create our delicious paintings, I want to give you a brief introduction and have you experiment and play with these techniques and explore the wonderful world of watercolors.

Wet-on-Wet

The wet-on-wet technique is one of the main and most common watercolor techniques. It means that we take a brush loaded with clear water and apply it to an area of the paper. Then, while that area is still wet, we drop in colors. This technique creates what you would refer to as a quintessential watercolor look. The water on the paper allows the colors to flow, mix, and spread within the wet area. As a result, this technique produces a soft look and feel.

A secondary take on the wet-on-wet technique is to mix your colors right on your paper. For this example, I started with a yellow. I diluted the pigment on the palette by grabbing some color from the pan and adding a few drops of water. I then loaded up my brush pen and painted the area. While the yellow area was still wet, I went back to my palette and loaded up my brush with pink. I then dropped in some of the pink on top of the wet yellow area. Since the paper was still wet, it allowed the pink to mix with the yellow, creating a smooth mix of the two colors. You can give this a try by adding some droplets of pink and watching them expand into the area. Or you can help mix the pink with the yellow by painting in circular motions on the paper. Experiment with this technique to discover the beautiful color variations you can get by mixing two or more colors.

Wet-on-Dry

Wet-on-dry is the next most common watercolor technique. It simply means that we load up our brush with color and start painting on dry paper. Because this book is about painting foods, we will often rely on this technique as it gives us the most control over the paints so that we achieve the desired watercolor effect. We will use the wet-on-wet technique as well, but not as much. You will notice that with the wet-on-dry technique our brushstrokes will have hard edges.

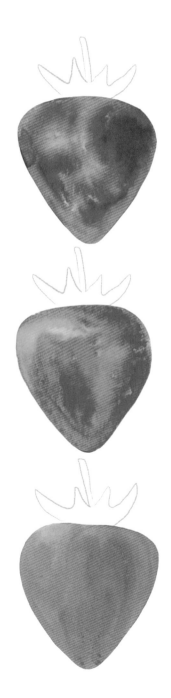

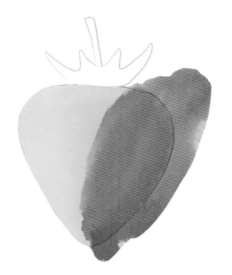

This is because we are painting directly on dry paper, so the pigment will form a hard edge once it dries, and the area of the painted shape will be more uniform as opposed to the soft look of the wet-on-wet technique.

Watercolor Glazing

Watercolor glazing is another common technique that sounds more complicated than it actually is. A glaze simply means applying a layer of paint over a layer that is already dry. Watercolor glazing is a great technique to use when we want to add more depth to a painting, because the more layers we add (allowing them to dry in between) the darker the value of the color will become, and as a result, it will look more vibrant and intense. We'll use this technique a lot throughout the book, because it allows for greater control when painting food.

> **NOTE:** *Some watercolor pigments are more opaque while others are more transparent. When using opaque colors, the glazing effect won't work as well as opaque colors won't allow the previous layer of color to show through the second layer. Glazing with transparent colors can create a beautiful glowing effect.*

Softening Hard Edges

This technique is fun and, as long as we're using the right paper, it can soften a hard edge. To soften an edge, we'll need to grab a damp brush pen and go over the edge of the shape we want to soften. Using a left to right motion of the brush pen, we're basically tickling the paper until the edge becomes soft and the hard edge disappears. This will work best if the area we're softening hasn't completely dried yet. But even if dry, it is possible to gently soften a hard edge.

> **NOTE:** *This softening technique won't work with staining colors (which most commonly are your reds or vibrant pinks and purples) because staining colors bind to the paper making it harder to lift off the paint.*

Dropping in Color

Dropping in color means that we load our brush pen with pigment that has been diluted in a few drops of water and then barely touch the paper with our brush pen tip. This way we are not exactly painting but we are simply "dropping" some of the color onto the paper so the little droplets can naturally blend within the area they are being dropped.

Soft Pastel Look

We won't be using this technique in our paintings, but I want to share it anyway to get you excited to experiment and play. This is an easy way to soften colors and desaturate them, hence making them look similar to pastel colors. After you paint an area or a shape with a color, while it's still wet, grab a paper towel and gently dab the area. The paper towel will absorb some of the color while some will remain on the paper. The remaining color will look desaturated, very light in value, but will still look nice.

Gradient/Ombré Look

This is another of my favorite techniques and it is perfect for when we want a smooth transition from a highly saturated color (the darkest value) to a very desaturated color (the lightest value, think almost paper white). To achieve this, we'll start with a simple shape and paint just the top area with a very saturated color of choice (you'll have more pigment than water). Then, while the painted area is still wet, we'll clean off our brush pen. The brush pen should be damp and have maybe just a drop of water in the bristles (by squeezing once on the pen). With the damp brush pen we'll apply pressure over the painted area so we'll use all the bristles (not just the tip). At this point, we won't be using any more watercolor pigment, but instead work with the damp bristles and the paint already on the paper.

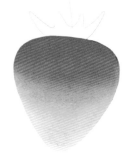

Apply pressure and then move the brush pen from left to right as you drag the color or the pigment down the page.

> **NOTE:** For this technique to work we must move and drag the clean brush before the color dries on the paper. It is similar to the softening the edge technique, but on a larger scale.

The result will be a look that goes from a very saturated dark value to a very desaturated light value. We are essentially diluting the color as we drag it down the paper and the introduction of more water (from the brush) allows for the color to become less intense, hence a lighter value.

Blending Two Colors Together

There are several ways to blend colors. The most common way to blend two colors is on the palette. We'll need to add a few droplets of water to the mixture and swirl it around the palette.

Another way to blend two colors is to do it directly on the paper. We can add a layer of watercolor on the paper and then, while the area is still wet, we can drop another color right into that same area (like in the wet-on-wet technique mentioned earlier). We can let the colors intermingle with each other on their own, or we can help the process by tilting the paper or even by using our brush pen to swirl the colors around the shape.

We can also use a variation of the previous gradient/ombré technique to blend two colors. We can start with one saturated color (so it's a dark value), then we can leave a blank space, and then we paint a second color. Now we can use the same technique as before and drag one of the colors into the other. Since we left a blank space between the colors, this will be the area where the colors will blend together into a nice soft transition. Essentially, we'll end up with three colors: the two saturated colors on each end and the resulting mixed color in the middle.

NOTE: To achieve the best results with this technique, be sure to have plenty of water in your pigment so it is easy to drag one color into the other. You can even squeeze one or two drops of water in the middle area to help the colors mix together. If the paint is too thick (meaning it doesn't have enough water to work with), it will be difficult to combine the colors on the paper.

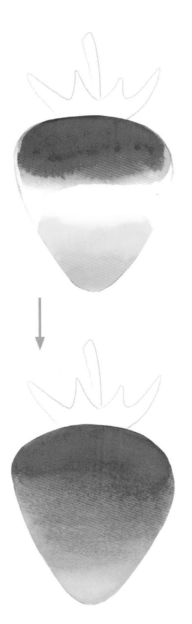

Lifting Off a Highlight

I love that watercolor allows us to essentially lift off a brush mark or some color to get a desired look or effect.

We'll start by painting in our strawberry shape with a solid color. Assuming the light source is coming from the left side, we'll add a highlight on that side by lifting off some of the color we just painted. To do this, while the paint is still wet, grab a clean brush pen and using pressure, drag it down the left side of the shape. After you have done this once, clean off the brush pen on a towel. Repeat this process (and the part about cleaning off the brush pen) a few times until you have lifted off enough color that a nice highlight has been created.

We can, of course, create a highlight by simply painting around a highlighted area, thus leaving that area of the paper unpainted. Many artists choose to do that. It is up to personal preference. I love the soft look of highlights using the lifting-off technique because it creates soft edges on the highlight and makes it look more natural.

Adding a Cast Shadow

A cast shadow is a shadow that is formed when an object casts a shadow on another surface such as the surface it's standing on. Following is one of my favorite easy ways to add a cast shadow to any object. It instantly will transform your flat shape or painting into something livelier, making it pop off the page.

While there are many ways of mixing colors to get a nice, gray-colored shadow, when you're painting on location you can just grab a little bit of Payne's Gray (which has a cool blue-gray look to it), or any black that you have on hand, and dilute it with a bit of water to create your shadow. I like the way Payne's Gray shadows look so I use that most often for a quick outline of a shape to give it more dimension.

You can either add a thin layer of water on the intended area (using the wet-on-wet technique) or you could do it wet-on-dry. Either way, you'll need to clean off the brush after the first layer and then help spread out the paint into a smooth transition from a vibrant value to a very light one (typically moving the brush from left to right to soften the edges).

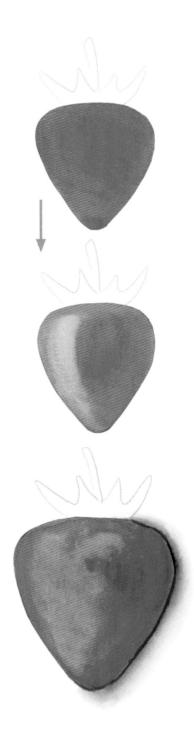

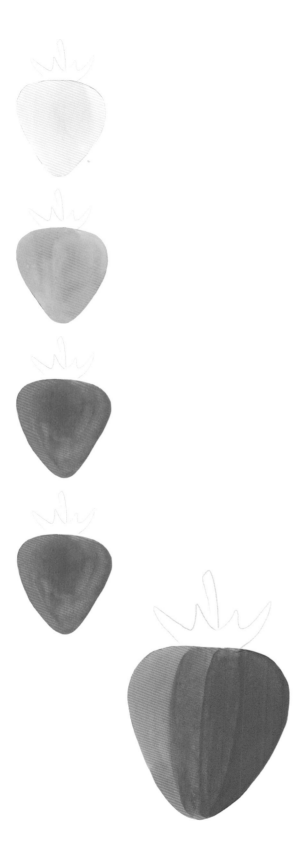

Painting Values from Light to Dark

Typically, with watercolors, we'll start painting with light values and will move onto increasingly darker values. This is because it is much easier to make a light value darker on the paper, versus making a dark value lighter; and this way we maintain more control. Super-realistic watercolor paintings can sometimes have up to 20 layers of watercolor, which means drying time is required between each layer, and as more layers are added, the values become darker.

For the purpose of creating successful food paintings, you'll find yourself painting two to three, or sometimes four, layers depending on which areas need a bit more depth. The darker values will indicate shadows (more layers typically) and the lighter values will show off those nice highlights (and will require fewer layers).

> **TIP:** *Watercolor will always dry a shade lighter than what you are working with. Keeping this in mind, you might have to experiment to see how the paint dries on your paper before deciding if it needs an additional layer.*

To paint your own value scale strawberries, you can do either of the examples shown. Make sure you have a pretty large puddle of color and water mixed together so you can maintain the same value (lightness or darkness of a color) throughout the four layers of painting.

1. Start with the first layer and paint the shape evenly and allow to dry.

2. Paint the second layer and allow it to dry.

3. Paint the third layer and allow it to dry.

4. Add the fourth layer and allow it to dry. You will notice the differences in value—from a very lightly colored strawberry to a much more vibrant/saturated one.

Color Theory Basics

Carrot Color Wheel

Color theory can be confusing, so I want to make it as fun as possible for you. We'll look at a carrot color wheel (because carrots are good for you and they come in many different colors).

Color theory plays a role when we try to mix colors and create compositions. Some colors play together really well (meaning they bring out the best in each other) while other color combinations not so much. Knowing the basics will help you make the best decisions until they will become second nature and you will intuitively know what colors look good together.

One thing to note: There are never truly any pure colors out there. They will either lean toward warmer or cooler temperatures.

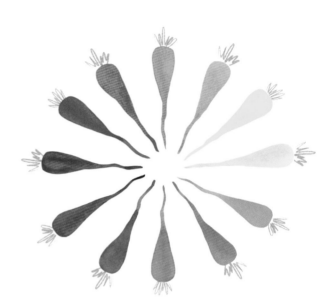

Primary Colors

Primary colors are red, yellow, and blue. These are the only colors that cannot be created by mixing other colors. All other colors are derived from these three colors, hence the reason they are the big cheese of colors.

Primary

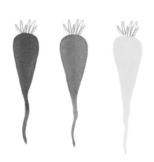

Secondary

Secondary Colors

These colors are derived from mixing primary colors:

- Think of your orange (red + yellow)
- Or purple (red + blue)
- Or green (blue + yellow)

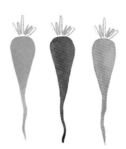

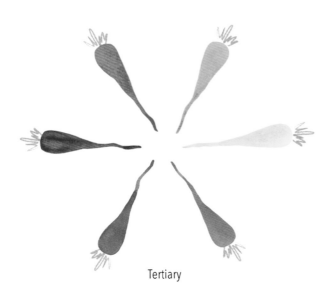

Tertiary

Tertiary Colors

This is the next level of the color wheel where we mix a primary color with a secondary color. For example:

- Yellow-orange (yellow + orange mixed together)
- Red-orange (red + orange mixed together)
- Red-purple (red + purple mixed together)
- Blue-purple (blue + purple mixed together)
- Blue-green (blue + green mixed together)
- Yellow-green (yellow + green mixed together)

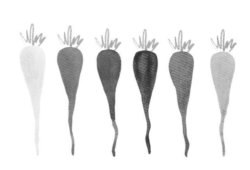

Complementary Colors

Complementary colors "complement" each other and, therefore, look good together (who doesn't like getting compliments?). They are opposite each other on the color wheel, and if you look at the breakdown, you'll notice something interesting:

- Red is complementary to green (green is a mix of yellow and blue)
- Blue is complementary to orange (orange is a mix of yellow and red)
- Yellow is complementary to purple (purple is a mix of blue and red)

Basically, we get complementary colors by using our primary + secondary colors (and the easiest way to remember them is that they are opposite each other on the color wheel).

When it comes to food painting and illustration, you'll start noticing a lot of dishes will incorporate complementary colors. For example, if you have a green leafy salad, you'd want to throw in some red cherry tomatoes to give it a vibrant contrast (i.e., they give each other compliments because they're nice and polite).

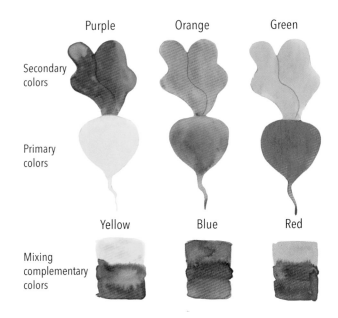

Another important thing to remember about complementary colors is that when mixed together on a palette or a painting, these colors will turn into mud. It happens so because, essentially, you are mixing together a primary and a secondary (which is composed of two other primaries) and therefore results in a muddy/gray color. This is useful to keep in mind because complementary colors are really great to use when you want to dull down a vibrant color or add a shadow that looks more natural than mixing it with gray or black. For example, if you have a painting of a green lime and you want to add a bit of shadow to it (e.g., on the shaded side of the form), you'd mix a bit of red into your green and paint a shadow that way. This will make your food paintings look better and more realistic because we are using the same colors, just a duller version of them (by mixing in its complement).

Quick note: I am referring here to the shadows you see on objects, not the cast shadows discussed earlier where we can use some Payne's Gray to achieve the effect. This is known as a form shadow, which depicts the shaded/darker side of a form.

- Opposite each other
- Bring out each other/make it vibrant
- But when mixed creates mud (great for shadows)

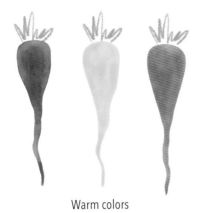

Warm colors

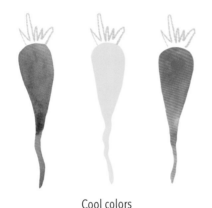

Cool colors

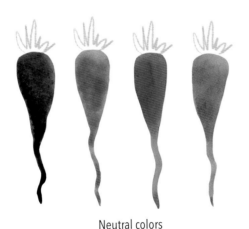

Neutral colors

Color Properties

A quick note about color properties. As I mentioned earlier, there are no pure colors out there. Even the traditional yellows (which is a warm color) can lean toward blue and therefore be cooler in nature.

Following are some important terms and concepts you need to know when painting with watercolors:

Warm colors: Warm colors make us think of warm things, like the sun, a pumpkin, or a banana. Some examples of warm colors are warm red, warm yellow, and warm blue.

Cool colors: Cool colors remind us of cool things like the sky, or water, or blueberries. Some examples of cool colors are cool red, cool yellow, and cool blue.

Neutral colors: Neutral colors are the colors you get when you mix two complementary colors. You won't see them on the color wheel, but you will notice them in a lot of baked goods that include chocolate chips, for example. Neutral colors include black and brown.

Hue: Hue is another term for "color." It is one of those technical terms that you might see in traditional art books. Basically, all the colors you see on the color wheel (your primary, secondary, and tertiary) would all be considered hues. They refer to the dominant color family. To keep it simple in this book I will refer to hues as colors in the following chapters.

Tone: When we add gray to a hue (or color) we get a tone. It is essentially a duller version of our main hue.

Saturation: The presence of black mixed in with a hue (color) will create a desaturation of it. And vice versa, when we have the absence of black in a mixture (where it's the pure color from a color wheel) the color will appear its most saturated and vibrant.

Value: The value of a hue (or color) will depend on the amount of water. More water creates a lighter value of our color. Less water will create a more vibrant, darker version of our color.

For value carrots: Start by painting a circle of your saturated color. Wipe off the brush and then use the damp brush to drag the color downward in sections. Wipe off the brush after every small section. Continue dragging down until the tip of the carrot becomes its lightest value.

Why is it so important to keep these terms and concepts in mind when painting with watercolors? All these concepts help us create more realistic and dimensional paintings. Knowing every term isn't necessary to just have fun with watercolor and paint some foods, but they will become essential when you want to take your painting to the next level. As we've seen in previous examples, shapes that aren't just one flat color are a lot more interesting to look at. And when painting foods and snacks, you'll start noticing those subtle differences (some areas will have a lighter value to show a highlight where the light source is hitting; other areas will be a darker value—and even a darker tone of the color—if it needs to indicate a shadow or the area farthest away from the light source).

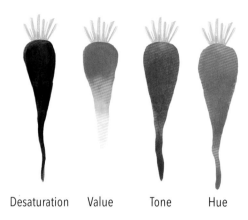

Desaturation Value Tone Hue

Mixing and Blending Colors

One of the best ways to get comfortable with using colors is to get to know them better! Think of this as an experiment and playtime where there are no expectations, just colorful circles or shapes.

I created these two mixing charts to show you what's possible when mixing colors. To create your own mixing chart you could either draw squares, rectangles, or circles (or any shape you like). I actually traced a piece of washi tape to get a few consistent circles on my page (which I then turned into little oranges).

We'll need to have three rows of five circles in this case. The circles on the top row of a group will have the colors that will come straight from the palette, meaning there will be just enough water to activate it but the hue itself will be super saturated and vibrant. We will then play with the different ratios of one color versus another to see how they mix together.

In my example, I started with Ultramarine Blue on the far left column. Before I switch out my color, since I have the Ultramarine loaded on my brush and it's really saturated, an easy way to create a lighter value of that color is to squeeze on the brush pen and release two to three droplets of water (you can squeeze onto a paper towel, for example), then we will paint the circle right below the first one. We won't be wiping the brush yet, because we want to keep using the same hue. For the third circle in that first column, we will release two more droplets and paint the third circle. The result should be a value progression from vibrant to light.

> **Tip:** *Remember, these are just guidelines and an approximation of the amount of water to add. If you feel the value of your second and third circles are too similar, then add another layer to the second circle (after it has dried) to create a noticeable difference. We are not doing a science experiment, but rather an art experiment!*

The next phase is to follow the same steps, but this time using Quinacridone Rose. Paint the three circles in the far left column, making each one a lighter value.

Next, we will want to play around with different ratios of these two colors combined. The middle circle on the top row will be a 50/50 mix of the two colors, so we just need to make sure we have an equal amount of each. Once we paint the top circle, using this color mix, we can do the same steps as before—adding more water—to get the two lighter values as we move down the column.

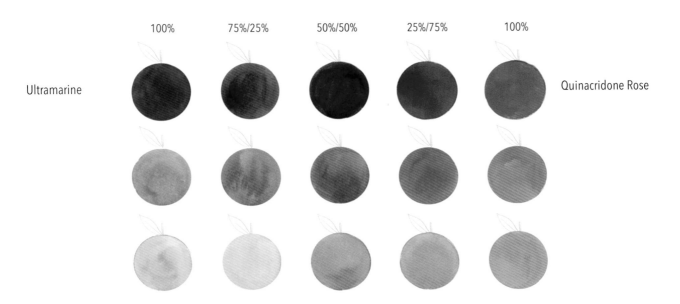

Ultramarine 100% 75%/25% 50%/50% 25%/75% 100% Quinacridone Rose

Next, we will work on the second column of circles, and that mix will be about 75% Ultramarine (because it's closer to that color in our chart) and about 25% Quinacridone Rose. Make sure to have lots of color when you're mixing so you get a pretty deep value for your first circle. Then we will follow the same steps and create the other two values below.

Finally, we will work on the fourth column of circles, and mix about 25% Ultramarine with 75% Quinacridone Rose. So, this mix will have about three times more Quinacridone Rose color in it than the Ultramarine. Do the same value exercise for the circles in the fourth column.

I've also created a chart using the same Quinacridone Rose but this time mixing it with New Gamboge. Take a look how the same color mixes in and interacts differently when another hue is introduced. I encourage you to experiment and mix any two colors together to see what you get. You may be surprised at some of the color combinations.

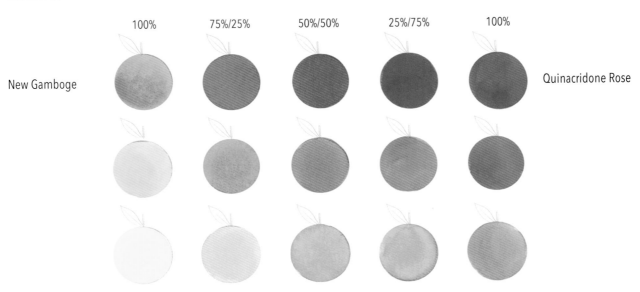

New Gamboge 100% 75%/25% 50%/50% 25%/75% 100% Quinacridone Rose

Square Color Chart

There is a type of chart you can create with all the colors of your palette. I highly recommend doing this, as it is a fun way to observe how your colors mix. I created an example using just four colors. I used thin washi tape to separate my squares so they look neat. At each intersection of the color on the top and the color on the left, we have a 50/50 mix of those two colors.

Since these colors will meet twice on our square chart, I kept the true value of the mixed colors on the right-hand side (if we separate the chart by a diagonal line) and a slightly lighter value on the left-hand side. This way I also can see the color mixes in lighter and darker values. Don't forget to write out the names of the colors in the same order on the top (x-axis) and down the left side (y-axis).

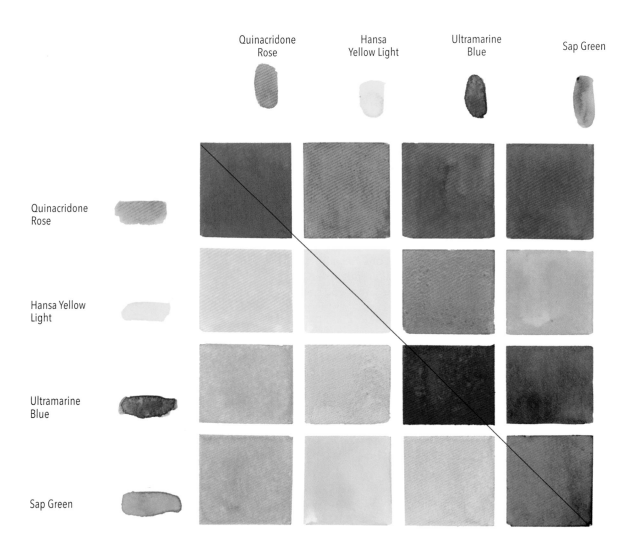

Form Shadows

As we can recall from the previous section, we can desaturate a color by adding black to it. Desaturating the color will make it look dull. If we want to add a shadow or make an area darker, it is not recommended to use black because the result will not look good. Instead, you can use a color that is its complement, or if you're painting quickly, you could use a color that is within that family but much darker in hue.

For example, if we have a lemon and we want to add a form shadow (the subtle shading on one side of an object), we could mix the yellow with its complement (which is purple) to paint the shadow area with that mix. Or we could use orange (another warm color but close to yellow) to give it a slight shadow area. Yet another way to add a quick shadow is to simply add a few more layers of the yellow color, thus creating a difference in value from the rest of the shape and defining the shadow area.

In my example, you will see three lemons showing various shadow options. The first lemon had yellow mixed with a neutral black, which resulted in a very dull yellow and not a pretty shadow. While this method doesn't look great on the actual shapes, a neutral black will make for a perfect cast shadow (the type of shadow created by an object that casts a shadow onto another object or surface).

The second lemon has a shadow created from a mix of yellow and purple. This is one of the best ways to add a shadow because from far away this shape will really pop (and you'll recall that yellow and purple are complementary colors).

The third lemon's shadow was created by mixing Cadmium Yellow Medium (a warmer color and closer to red) with the basic Cadmium Lemon. The result is OK and while it works, it isn't as vibrant as when we use a complementary color to create a shadow like in the second lemon.

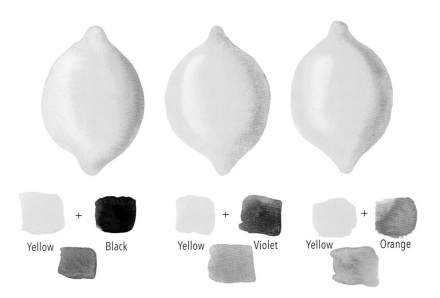

Yellow + Black Yellow + Violet Yellow + Orange

Common Watercolor Problems (and How to Fix Them)

Muddy Colors

Muddy colors result when a mixed color isn't vibrant. Even though those neutral or muddy colors could work great in some areas, typically, they don't produce the desired outcome. They are out of place on your paintings.

Several things can cause colors to appear muddy. The first cause to consider is that your water is dirty. In our case, if we're using a water brush pen, the chance of that happening is minimal because we are constantly working with clean water from inside the brush pen. However, if you use a traditional brush and a jar of water, depending on the colors you use, you could end up introducing dirty water onto your painting, thus causing a muddy look to it. The best fix is to change the water as soon it begins to look dirty.

Another cause of muddy colors could be the use of too many colors all at once or using too many brushstrokes (or overworking). Introducing too many colors that are mixed together, or that are layered on top of each other, increases the chances of muddy colors. Try to limit yourself to two colors if you are mixing and keep them in the same family of colors. (You may recall that mixing complementary colors together will create a muddy look). Decreasing the number of brushstrokes in one area may also help avoid getting a muddy color.

If color mixing is still challenging for you, try to create various color charts and mix two colors together to observe what happens. Oftentimes, having that visual aid and the applied experience of mixing colors can help with remembering which colors are most likely to appear muddy when mixed together.

Another cause of muddy colors could be a dirty palette. Try to keep your mixing area as clean as possible when starting out so you have a clean base to work with. If you're working with a palette that has some old paint dried up on it, you could accidentally introduce that color into a new color, which could result in a muddy, dull look.

Keep your colors separate and if you added some brushstrokes of another color into a watercolor pan, clean it off by wiping the surface with your wet brush. This will ensure that you are working with the most vibrant version of that color, uncontaminated by other colors.

Water Control

Water is your best friend when it comes to painting and enjoying watercolors. But how much is enough?

For the purpose of creating watercolor snack paintings, we won't be using a lot of water. The reason is that many of the elements we'll be painting will require more control than some of the traditional watercolor painting exercises. I encourage you to experiment and definitely play around with various amounts of water when you're practicing or warming up. For the food paintings though, we won't be using water to the point where it's dripping off the paper. The amount will mostly resemble a soft glisten on the paper (not forming any puddles or beads of water). However, even if it's dripping off the page, we have an easy solution for that!

Too little water

Too much water
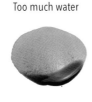

Right amount of water
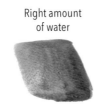

A paper towel or tissue paper will come in super handy in those instances where there is just a little bit too much water. Dab the edge of a paper towel on the area that has the water and it will absorb the excess drops so we can regain control of the painting.

You will notice that your paper has too much water on it when you see a pool of water forming. You can easily lift that excess water with the help of a paper towel or even with a barely damp watercolor brush.

If you notice that your paintbrush is leaving streaky texture or visible brush strokes within the area you're painting, it means you are not using enough water. If you're using a water brush pen, simply squeeze on the barrel to release one drop of water at a time.

With food paintings, we want to have more control over the water. You could release one or two drops at a time from your brush pen, but not more. That way you will maintain control over the painting and the area will dry more evenly. You will know you have enough water when the surface is glistening evenly, without puddling in one area.

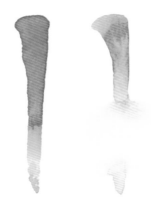

Accidental Marks

Depending on the color you're using and whether or not it's a staining color (meaning that it forms a close bond with the paper's surface and is therefore hard to lift off), you might be able to fix some accidental watercolor marks.

If the paint is still wet on your accidental mark, use a paper towel to gently lift off that area. You could also use a damp brush, and using a left-to-right motion, essentially "erase" the mark. If the color is truly non-staining, you can also lift it off after it has dried. Just use a wet brush to go over that area and gently "erase" it. Staining colors vary by brand and the best way to learn which colors on your palette are staining is to test them out and experiment.

Thick Paint

Since water is our best friend, it is always a good idea to either start with a puddle of water on the palette or keep adding droplets (by squeezing on the brush pen) into the area where we're mixing the color. Thick paint will result when you're using a lot of pigment and not enough water.

Cauliflowers and Blooms

Cauliflowers (also known as blooms) can be pretty but they can also be frustrating if we didn't intend for them to happen. They typically will happen with watercolors when we add a drop or two of water or watery paint inside a painted area that is still wet and not completely dry. Essentially, the extra water we add on top of the semidry area will push the pigment to the edges of the area, which creates a cauliflower effect. To avoid this, be patient with the drying time of an area and do not introduce more water before that area dries. If you want to fix an accidental cauliflower shape, you can do so by using a damp brush and using circular motion, try to soften the harsh cauliflower lines. A motion of left to right and backward could also help smooth them out.

Cauliflower formation (on the left) and softened cauliflower lines (shape on the right).

Bleeds

Sometimes a color from one area will bleed into another color. This usually occurs when we start painting next to an area that hasn't yet dried, so the presence of the water makes the colors bleed together unintentionally. You can easily fix this by allowing the area to dry completely and then painting over one of the shapes in the same color as before, reinforcing the dividing line. If the bleed is of a darker value, we could also wet the entire area with a layer of water and lift off one of those colors to correct the lines between the shapes.

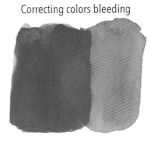

Colors bleeding Correcting colors bleeding

Glazing Before the Paper Dries

A common mistake when glazing is not allowing each layer to dry completely. When we don't let the first layer dry, we create an opportunity for two colors to mix together on the paper instead of being layered one on top of the other.

Before first layer dried

After first layer dried

Granulation

Granulation can be caused by substances that are present in some paints. Typically, granulating paints do not create a smooth wash as they will have some particles or granules that will be visible on the paper. The only real way to avoid this is to test your colors or purchase non-granulating colors. But even if you do encounter granulation, I encourage you to play and experiment with that color. Sometimes you can get beautiful textures with these types of pigments, which may add interest to your paintings.

Unstretched buckling Stretched with washi tape

Paper Warping and Buckling

The main cause of paper warping or buckling is too much water used on thin paper. Even with paper designated for watercolor, buckling can occur when too much water is used in the process. This is why it's important to use the heaviest paper you can find (I recommend 140 lb or higher). An easy way to prevent paper from buckling is to use washi tape to tape your paper down to a flat surface. Allow your painting to dry completely before removing the tape.

Adding a Highlight with White Gouache or Acrylic Paint

If you weren't able to lift off a highlight or you'd like to be more dramatic and add contrast on a shape, a simple way to achieve this is to use either white gouache or an acrylic paint marker (like a POSCA paint marker pen). Because of their opaque property, these two options will provide an easy way to add highlights to your paintings.

Uneven Layers and Streaky Washes

If you notice streaks in the shapes you're painting, this typically means there isn't enough water to allow the pigment to spread evenly. One easy solution is to simply add a little bit more water and then even out the wash. To achieve a perfect wash you will need to use a traditional brush that can hold plenty of watercolor in it to allow for an even distribution. You will also need to tilt your paper at an angle of about 45 degrees and paint from left to right and vice versa as you're painting the whole shape. You can do this with a brush pen too, but because the bristles on the brush pen are fairly small and can't hold a lot of water, you might still see some streaks, but if you follow the same method as with a regular brush, you can still get a pretty even wash of watercolor.

Even layer with traditional brush

Uneven layer

Even layer with brush pen

Keeping up with a Watercolor Sketchbook Habit

I often encounter fellow artists and blog readers who mention that they just don't have the time to keep up with a sketchbook or art practice. They ask me, "How do you find the time to do it all?" I used to think the exact same thing. I actually found from experience that it was during the busiest time in my life that I most craved some sort of creative release. A few years ago, I was working a full-time job while going to school for my master's degree. I basically had no days off and no social life because every free moment after work was dedicated to working on assignments, writing essays, or prepping for tests. I was quite stressed, but above all I just wanted something totally different (I was doing lots of analytical writing, very much right brainy stuff). I found my solace in doing art and that was when I dug out my tucked-away, empty sketchbooks and started filling them up.

Here are some suggestions to get you started on your own sketchbook habit:

Start Small. It's important that you start super small to build your watercolor sketchbook habit. You have to start with just a few minutes a day and work yourself up to increasing that time; otherwise you won't be able to do it consistently. When I first got started, one of the things I did was to paint with watercolors 10 minutes before going to sleep. I made it easy on myself by having a mini sketchbook with less than perfect pages by my bedside and a brush pen to paint with. I would just paint what was in front of me: sometimes it was my husband brushing his teeth, sometimes it was just my blanket with my feet underneath it, and sometimes it was a scene I'd seen on TV. Dedicate some time to painting in your sketchbook and get it done. I even recommend having a timer or stopwatch going so you have an end in sight.

Be Consistent. Make yourself a little calendar and mark an X on it every time you paint in your sketchbook. This is actually a well-known practice from Jerry Seinfeld who used this technique to write jokes every day. The idea is that it's satisfying to see a large streak of X's on your calendar, which indicates that you stuck with a thing. Why not make that thing your sketchbook practice and it could be for only 10 minutes a day? At the end of the month, you may find yourself having done 300 minutes worth of watercolor painting and that's way better than just doing a sporadic painting for 20 minutes once a month.

Make it portable. One of the reasons I started with watercolors was because of the portability of the medium (and the brush pen). For a long time, I was so fascinated with making pocket watercolor palettes and making them tiny and cute so they could fit in my pocket or purse. Your watercolor sketchbook and painting materials don't need to be huge and when you start with something that is portable that you can carry upon your person, it decreases the barrier of having to "set up" a giant table with paper, paints, palettes, water containers, and so on. It removes all that and allows you to get straight onto your art.

Make it visible. Another little trick I've found useful is to leave my art supplies in a visible spot. For me this is our dining room table. I just leave some of my things in one corner and this way when I am eating breakfast or lunch I can see them and be inspired to pick them up and either paint something I want or what is right in front of me (usually it will likely be food). If you don't have the option of leaving your supplies out on your dining table, perhaps you can leave them by your couch where you typically watch TV. Next time there is a commercial or you don't need to pay too much attention to what is going on, pick up your sketchbook and start doing some watercolor painting.

Join a challenge. To help you with your streak of keeping up your watercolor sketchbook habit, join a challenge. There are many great websites and social media accounts that can give you an idea each day to do something creative, small, and quick. Here are few fun challenges I've been a part of:

- They Draw and Cook: https://www.theydrawandcook.com/
- World Watercolor Month: https://doodlewash.com/world-watercolor-month-july/
- The 100 Day Project: https://the100dayproject.org/

Get up early. Finally, this is something that can be quite obvious but might seem unattainable. Try getting up just 15 minutes earlier than your regular routine and use the time to play with watercolors as your first activity of the day. I can guarantee you it will feel really good to have taken the time to do something that matters to you. It will also feel like you've already had a win for the day so you're likely to be in a better mood and, therefore, will be able to pass that on to others.

Chapter One

Breakfast

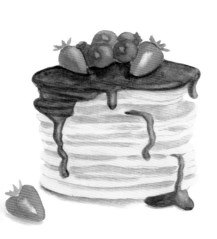
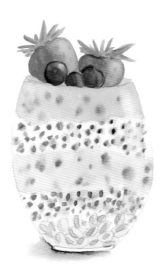

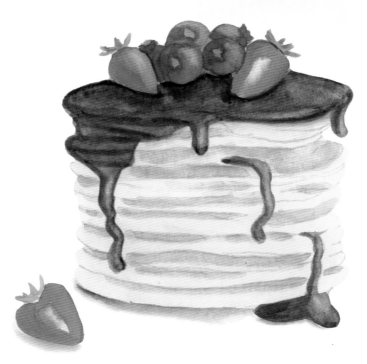

Pancakes

Yellow Ochre	Raw Sienna	Carmine	Ultramarine Blue	Burnt Umber

What's better than a fresh stack of delicious pancakes and chocolate syrup on a Sunday morning? Maybe having—or painting—your pancakes and eating them too! After you've sketched your stack of pancakes, grab your medium sized brush pen.

To sketch your pancakes, start with a series of slightly curved and irregular lines, one after the other. The very last pancake on the top will resemble an imperfect narrow oval shape. The berries will be a series of circles and rounded triangles for the strawberries.

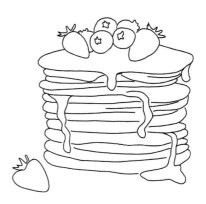

Mix some Yellow Ochre with a few drops of water so you have a nice light value of the color on your palette. Cover the whole area of pancakes with a light layer of this Yellow Ochre. Leave the berries blank for now. Allow this first layer to dry completely before proceeding to the next step.

Use more Yellow Ochre and paint a thin layer on parts of the pancakes, indicating the flat, browned faces of the pancakes in your stack, while the sides of each pancake should remain a light value. After this layer has dried, paint over these same areas again with the Yellow Ochre to build up the depth of color. Allow the paper to dry.

Using a little bit of Raw Sienna, paint a thin layer over the same areas that you just painted.

As that layer dries, we will work on the berries. Make sure your brush is clean, and without adding much water (mostly just using the damp brush), cover the strawberries in a thin layer of water; just enough to get the paper wet, as we will use the wet-on-wet technique. Now drop in some Carmine for the strawberries, leaving the middle part of the sliced strawberry blank.

After the strawberries have dried, using a clean brush, apply a thin glaze of water over the blueberries and then drop in some Ultramarine Blue to cover the whole area of the blueberries. Use Sap Green to add little strawberry leaves using the wet-on-dry technique so we have more control over those tiny areas.

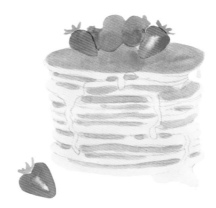

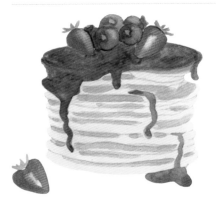

Next, we're going to work on the chocolate syrup. Using some Burnt Sienna from your palette, paint a thin glaze layer on the top of your stack and add some for the drips on the sides.

While our chocolate syrup is drying, with a clean damp brush, lift off a few highlights on the berries. Our light source is coming from the right-hand side, so the highlights will be on the right. Add another layer of blue on the blueberries and red on the strawberries, making the left sides a deeper value while keeping the highlights on the right.

Mix in a little bit of Burnt Umber with Violet to get a much deeper, darker brown. We'll use this brown to add some shadows on the chocolate syrup and shadows just below the berries. Outline a few of the pancake lines that are covered by the chocolate syrup with this color. Next, lift off a few highlights on the syrup to match the rest of the sketch.

Optional: You can add a bit of a cast below the pancake stack by using a very diluted Payne's Gray and painting a thin layer just below the bottom of the pancakes. Such a shadow helps to anchor an object so it doesn't appear to be floating on the page, as well as adds dimension to our painting.

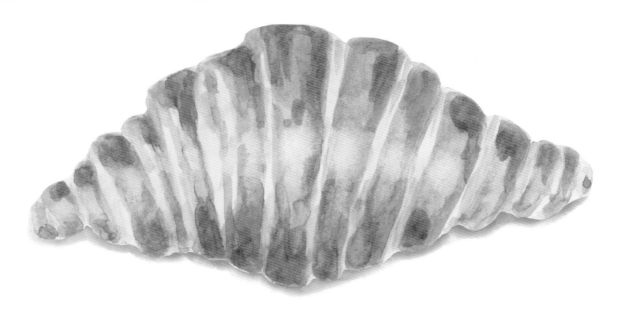

Croissant

Yellow Ochre

Raw Sienna

Burnt Sienna

Croissants will always have a special place in my heart. I remember eating chocolate croissants growing up in Moldova, always excited to get to the chocolate filling.

To sketch the croissant, you can start with the middle, sketching an irregularly rounded rectangle. Then you'll build up the shape by decreasing the size of your lines and varying in width between each line as you work outwards.

After you have your sketch ready, use your brush and apply a thin layer of water over the entire croissant for the wet-on-wet technique. Next, drop in Yellow Ochre and spread it over the whole shape. Allow this to dry completely.

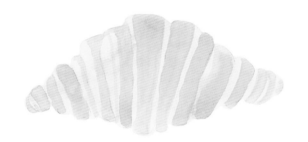

Next, we'll load the brush with more Yellow Ochre and paint a few lines of varying widths on the crois-sant (simply adjust the pressure of your brush on the paper to vary the width of a line). Leave some space in between these lines, allowing the first layer to shine through as a lighter color.

After your paper is dry, use a little bit of Burnt Sienna diluted with a few drops of water and paint this over the same areas as in the previous step. We're slowly building up our layers. Leave some blank spots in the middle parts of the croissant for highlights (the light source is coming from the top, center). With a clean, wet brush pen, gently blend the Burnt Sienna with the layer underneath.

After the layer has dried, use a clean, wet brush to lift off more highlights down the center of the croissant, so the highlights really pop.

Mix some Burnt Sienna and Yellow Ochre, and with quick, light brush strokes, use this to add some thin layers of lines around the croissant, to deepen some of those golden browns and to showcase the flakey croissant.

Optional: Add a subtle shadow below the croissant by using a very diluted Payne's Gray and painting a thin layer just below the bottom of the croissant.

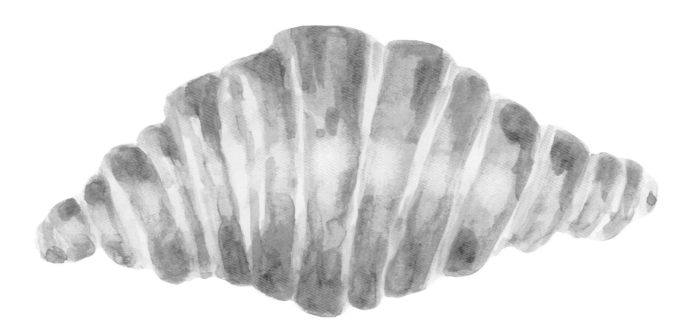

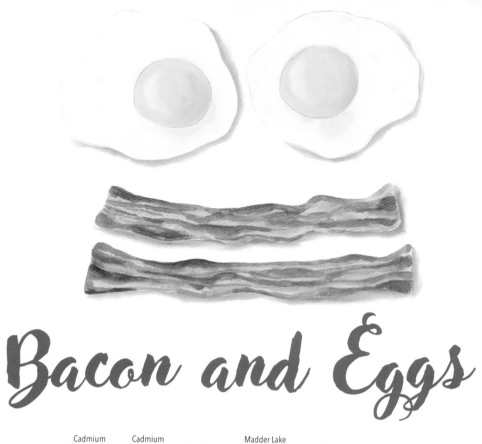

Bacon and Eggs

| Cadmium Yellow Medium | Cadmium Orange | Raw Sienna | Madder Lake Red Light | Burnt Sienna | Bacon color |

Bacon and eggs is one of those quintessential meals I absolutely love to have any time of day. There's just something about those yellow yolks that bring me so much joy.

To sketch the egg whites, draw large wobby circles and for the egg yolks, sketch more rounded shapes. The bacon strips are a series of wavy lines composed inside a wobbly and irregular rectangle shape.

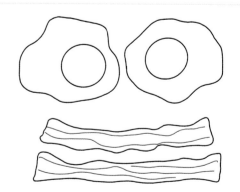

We're going to start with the wet-on-wet technique for this painting. With your brush pen, squeeze just a drop of water into the yolk part of the eggs. Spread a thin layer of the water completely over the yolk.

Take your Cadmium Yellow Medium and drop some inside the wet area, and then spread the yellow over the entire yolk with your brush pen. For this project we will assume our light source is coming from the left. While the paint is still wet, drop a little bit of Cadmium Orange to slightly darken the right side of each yolk. Then, with a clean, damp brush, lift off small highlights on the left side of each yolk.

Similarly, for the bacon strips, we will use the wet-on-wet technique. Wet the entire area of both bacon strips. Drop in some Burnt Sienna and spread it over the strips. While the bacon is still wet, drop in just a few areas of Raw Sienna. This will create a very light layer of color on the bacon. Allow the paint to dry completely.

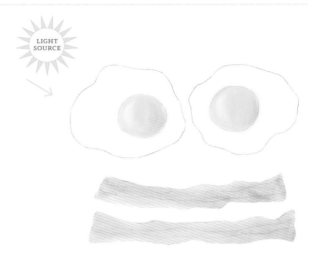

LIGHT SOURCE

Next, add another layer of Cadmium Yellow Medium and glaze it over the yolk while keeping the highlight uncovered. Next, add a layer of water to the egg white, coming in close to the yolk. The yellow from the yolk will bleed a little into your wet area, and that is just part of the fun. Use a little Raw Sienna to add short and quick wiggly lines inside the egg white to create the texture of the fried egg.

For the bacon strips, which should be dry by now, mix some Madder Lake red with Burnt Sienna, for a nice reddish-brown color. Load some of this on your brush and paint some wobbly lines on the bacon. These lines will vary in width, with some being wider, some narrower. That's the fun part—they don't have to be perfect. Next, use a little bit of Cadmium Orange and drop it in some places too.

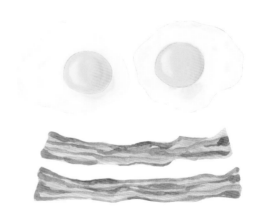

For the last steps, you can add another thin layer of Cadmium Yellow Medium, glazing it over the yolks so they really pop (remembering to save the highlight). And for the bacon strips, add more wavy lines using Burnt Sienna and Cadmium Orange. These colors will make your bacon strips look cooked, crispy, and delicious.

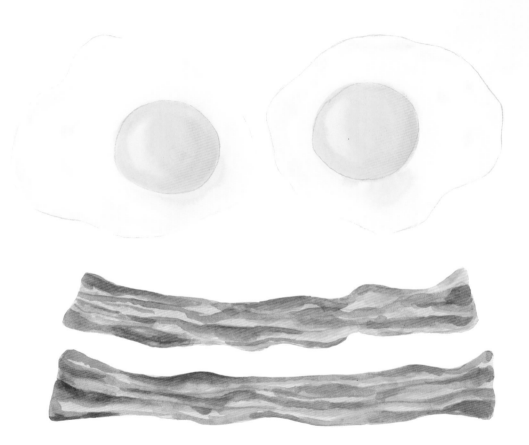

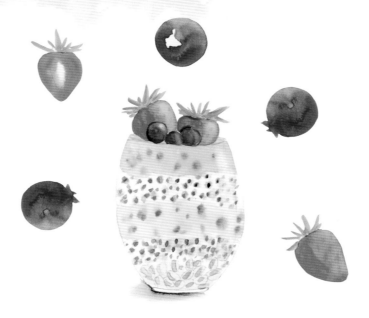

Breakfast Parfait

Opera Pink DS	Payne's Gray	Raw Sienna	Ruby	Sap Green	Ultramarine Blue	Yellow Ochre

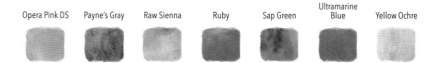

Breakfast parfaits are so much fun to paint and to eat! They come in many different flavors and my favorite ones are the most colorful.

To sketch the glass, you'll draw two curved lines that mirror each other. Then you'll connect the two vertical lines with a flat line at the bottom and a curved line at the top. Separate the parfait layers with wobbly lines and sketch the berries using rounded triangle shapes and circles.

We'll start at the bottom of the parfait glass, with the oatmeal. Use Yellow Ochre to paint a thin layer covering the oatmeal. Next, we will use the wet-on-wet technique to add in the chia seeds and the strawberry yogurt. Add a very thin layer of water, and then drop in Payne's Gray as small dots. These dots will bleed on the wet paper. Allow to dry. Next, add a layer of Opera Pink, covering the area for our yogurt layers. While the pink is still wet, drop in a few dots of pink to indicate the small strawberry pieces in the yogurt.

Once the painting is dry, lift off a highlight with a clean, wet brush, on the right side, dragging the brush downward over all the areas of the glass. Then, with a little more Payne's Gray on your brush, add more chia seeds on top of the areas designated for them. This will give your painting some dimension and these dots will appear as more defined seeds. The seeds will resemble small ovals or dots and don't need to be perfect.

Next, use some Ruby and paint the strawberries using the wet-on-dry technique. Remember, our light source is on the right side, so you will want a highlight there as well (lift off with a clean wet brush). Paint a thin layer of strawberry leaves with Sap Green.

Once the strawberries are dry, paint the blueberries with Ultramarine Blue (again using the wet-on-dry technique to give us more control over these small areas). The blueberries will have highlights as well, similar to those on the strawberries.

Allow the paint to dry completely. Load a little Yellow Ochre on your brush and add quick lines on the oatmeal pieces. These darker lines will act like shadows and will add more dimension.

Paint another layer of Ruby on the strawberries, keeping the highlights there. Once those are completely dry, take a little bit of Cadmium Yellow Medium on the tip of your brush and add little strawberry seeds. Also, go over the strawberry leaves with more Sap Green to give them more dimension as well.

Optional: You can add a slight shadow below the glass. With a little bit of Payne's Gray, paint a thin line right below the glass, moving toward the left. Then, with a clean damp brush, smooth out the line to create a shadow that transitions from dark gray to light gray.

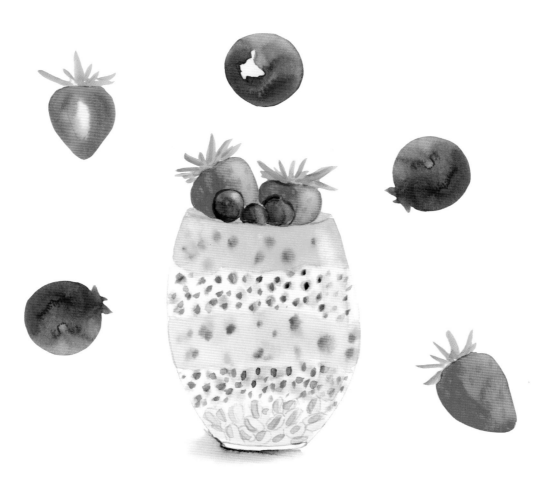

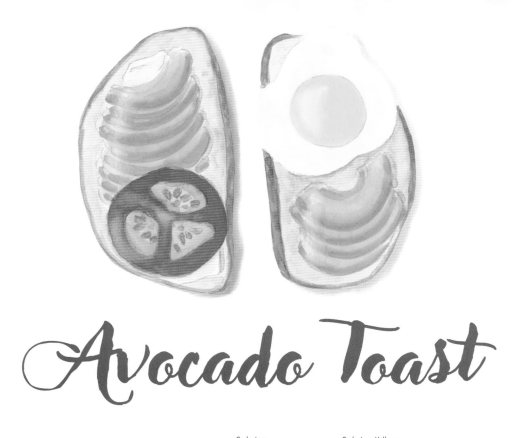

Burnt Sienna	Violet	Yellow Ochre	Ruby	Cadmium Orange	tomato color	Cadmium Yellow Medium	Sap Green	avocado color
				+	=		+	=

It wouldn't be a proper breakfast without an avocado toast! These bring back fond memories from when I used to eat them in Argentina while studying abroad there many years ago. In recent years I've also learned about the health benefits of eating avocados.

To sketch the toast, start with an almost oval shape, with one end being somewhat pointy. The avocado slices will be a series of curved lines, and the tomato will be a round shape with rounded triangles inside. The egg white is a wobbly circle with egg yolk being round.

Start by mixing Sap Green with Cadmium Yellow Medium. You should get a nice avocado green color. Paint a thin layer of green on the avocado pieces. Use Cadmium Yellow Medium for your egg yolk and lift off a highlight with a clean brush.

Mix a little bit of Ruby with Cadmium Orange to get a warm red color for the tomato. Add a thin layer of your red mixture on the tomato's edges and veins. After the edges of the tomato have dried, add a thin layer of Cadmium Orange (diluted with water for a light value) for the inside part of the tomato.

Next, use Yellow Ochre to paint the bread slices, covering the area completely. While that is still wet, add tiny specks of Burnt Sienna to create the bread texture. Wait for that layer to dry, then also use the Burnt Sienna to outline the toast slices and the wider parts of the crust.

Next, using your Sap Green and Cadmium Yellow Medium mix, paint thin lines outlining the edges of the avocado slices. Then, with a clean wet brush go over those lines to smooth them out a bit.

Grab a little bit of Cadmium Yellow Medium and add another a thin glaze on top of the avocado slices for a bit of added vibrancy. Lift off small highlights on the left side of each avocado slice (to match the egg).

Add a little bit of the mix of Cadmium Orange and Ruby for the tomato seeds.

Repeat the avocado outlines to make them even more vibrant. Go over the crust of the toast with another layer of Burnt Sienna. Add a mix of Violet and Yellow Ochre for a dull yellow to make a shadow underneath the egg on the right side. On the egg white area apply a thin layer of water and drop in a few quick lines of Yellow Ochre to give it some texture.

Add another layer of your Ruby and Cadmium Orange mix on the tomato outline. On the inner parts of the tomato slice, with a clean wet brush, drag in a little bit of the red from the outer edge of the tomato. Lift off a few highlights on the tomato slice as well.

You can experiment and add different toppings to your avocado toast. Try small slivers of purple onion, or a few radishes that are just little circles painted with the wet-on-wet technique using a little bit of pink on the edges. Other options are to add small cherry tomatoes or basil leaves.

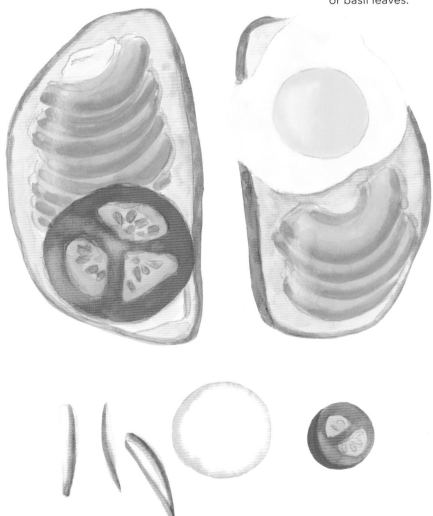

Chapter Two
Lunch

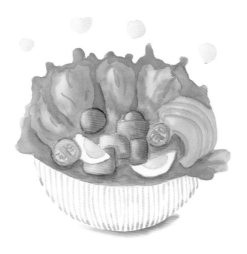

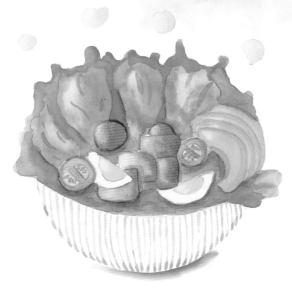

Salad

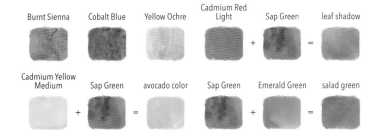

Burnt Sienna	Cobalt Blue	Yellow Ochre	Cadmium Red Light		Sap Green		leaf shadow

Cadmium Yellow Medium		Sap Green		avocado color	Sap Green		Emerald Green		salad green

Salads are always fun to paint—and eat—because they typically include lots of colorful ingredients.

To sketch the salad, start with the bowl, which will resemble a crescent moon shape. The salad leaves will be a series of wavy and wobbly lines. The rest of the shapes are either circular for the tomatoes or square for the meat, with curved lines for the avocado slices.

We'll start with the leafy greens of our salad. With your water brush pen, squeeze a few drops of water on your palette and add some Sap Green, to make a nice puddle of color. Paint a wash of Sap Green onto the leafy parts.

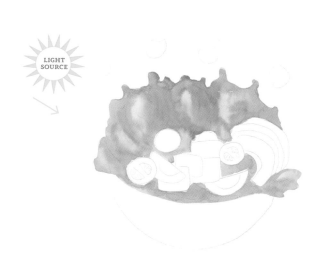

While the paper is still wet, lift off a few highlights: in this case the light is coming from the left side so the highlights will be on the left. Also, while it is still wet, drop a little bit of Emerald Green onto that first layer. Use your brush to help the two colors mix and mingle in a natural flowing way, keeping the highlights un-touched. You can add a little bit more Emerald Green to the leaves at the back of the bowl.

If your first layer dries too quickly for you to drop in the Emerald Green; make sure the whole area has com-pletely dried and go over it again with your clean, wet brush for another quick glaze of water and then drop in more Emerald Green.

After your paper has completely dried, mix Sap Green with Emerald Green on your palette to get a nice rich green. Use this to paint over the leaves of the salad at the back of the bowl, painting around the closer leaves so they remain lighter. Add just a few thin brush strokes here and there on the closer/lighter leaves to show a few folds. This technique is known as negative painting because we are essentially painting some of the negative space around our main salad leaves.

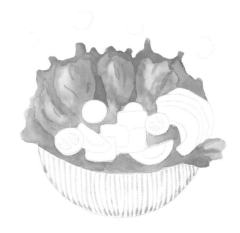

While the lettuce area dries, we can work on the salad bowl. You can get creative with this and decorate it however you want. I will keep it fairly simple with just a series of thin lines using Cobalt Blue. I use barely any water here, just a bit from the palette where the color is mixed so I have more control over the lines. I use very little pressure on the brush pen so my lines are fairly thin.

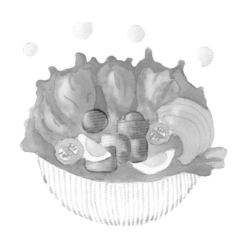

Next, we'll work on the rest of the ingredients using the wet-on-dry technique. For the avocado, mix Sap Green and Cadmium Yellow on your palette. This mix should give you a nice avocado color. Painting wet-on-dry, paint a layer of this mix on the avocado slices.

Use some Cadmium Red Light and paint the tomatoes and tomato slices. While the tomatoes are still wet, lift off tiny highlights on the left sides.

Paint the egg yolks using Cadmium Yellow Medium. You can lift off tiny highlights on the yolks to give them more dimension.

For the meat pieces, we'll use Burnt Sienna. Grab a bit from your palette and paint the meat squares, and then lift off a few highlights (always keeping your highlights on the left to match the rest of the painting). While it's still wet, you can add a little more Burnt Sienna on the right side to increase the contrast.

Mix Cadmium Yellow Medium and Cadmium Red Light for a nice orange and paint the tiny tomato seeds on the slices.

For the dancing chickpeas, use Yellow Ochre diluted with water a little so it's a nice, light shade. Maintain the highlights on the left side as well.

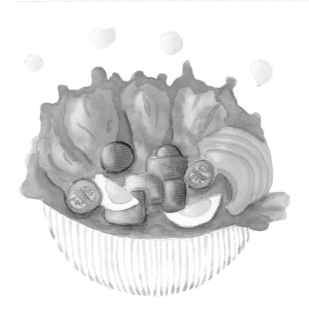

The few final steps will involve adding a bit more depth to our painting. Create a mixture of Sap Green and Cadmium Red Light adding enough water so it is a fairly light value. It will look a bit muddy and brownish but will work great to add some shadows. These will be almost like outlines on some of the ingredients to show they are casting shadows on the green leaves.

Use a bit of the avocado green mix from the earlier step and add a few thin lines to distinguish between the avocado slices.

Using your Cadmium Red Light, add another thin layer of color over your tomato slices, maintaining the highlights. You can also add a few thin brushstrokes on the protein slices to show shadows casting on different pieces.

Finally, with a little bit of Payne's Gray add a quick shadow underneath the bowl.

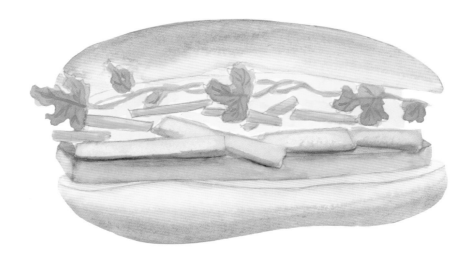

Bánh Mì

Cadmium Yellow Medium	Emerald Green	Golden Deep	Raw Sienna	Sap Green	Yellow Ochre	Quinacridone Red	Burnt Sienna	meat color

One of my favorite experiences when it comes to food is hearing the sound as I bite into a crunchy, fresh bánh mì. Hearing that baguette crackle adds so much excitement to the moment.

To sketch the bánh mì, start with the buns, leaving plenty of space in between for the fillings. The bun shapes will be wavy lines, forming a general curve of the shape. The meat, carrots, and cucumbers will be rectangular, and the cilantro leaf will be a series of wobbly lines.

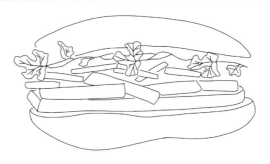

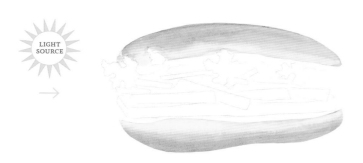

LIGHT SOURCE

For our bánh mì, we'll start with the wet-on-dry technique, diluting a little bit of Yellow Ochre with water. We'll work on one bun at a time to prevent the layers from drying. Cover the top bun with Yellow Ochre, and while that area is still wet, drop in some Raw Sienna. This will create the golden-brown delicious look to the bun. The Raw Sienna will go near the top, so the edge that is closest to the other ingredients will remain fairly light. Also, lift off a small highlight horizontally across the length of the bánh mì.

Follow the same steps for the bottom bun. In this case, the bun will remain lighter toward the top and the highlight will be on the edge closest to the ingredients. Add the Raw Sienna along the bottom.

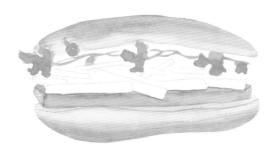

Allow the paper to dry completely. Take a little bit of Yellow Ochre diluted with water, and on the bottom bun, apply it to the area right underneath the meat slice.

Allow the paper to dry completely, then mix some Quinacridone Red with Burnt Sienna, adding several drops of water to make a fairly light color. Use this to paint the entire meat slice. Then, with more Burnt Sienna diluted with water, paint over the top area of the meat slice again, while that area is still wet from the first layer, right underneath the cucumber slices. Slightly lift off some areas to give the meat slice some variation in value.

While the meat area is drying, we can work on painting the first layer of the cilantro leaves. Dilute a little bit of Sap Green with water and paint it on the cilantro leaves and stems.

Drop a little more of the Sap Green on some parts of the leaves to vary the value of the green, making some areas lighter and others a little darker.

Mix some Sap Green with a little Emerald Green and dilute it with lots of water to get a very light value of a green color for our cucumber slices. Paint those areas, and while still wet, lift off a few highlights so the resulting value will be light and airy, the color of a cucumber slice. Then, with some Sap Green, paint thin lines across the bottoms of the cucumbers to show a little bit of the skins.

While the cucumbers are drying, use the same Sap Green and Emerald Green mix to paint thin wavy lines inside the cilantro leaves to give them more dimension.

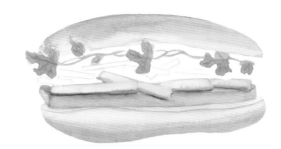

Next, use Cadmium Orange diluted with water to lightly paint the carrot slices. Lift off some horizontal highlights to give them some dimension. You will be using very little water, which will give you control over those tiny carrot shapes.

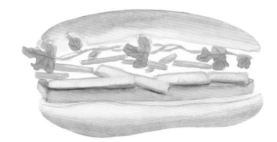

Finally, dilute Cadmium Yellow Medium with lots of water to get a very light value of the color. Use this to fill in the blank spots around the carrots and the cilantro leaves. This will illustrate our aioli on the bánh mì, bringing it all together.

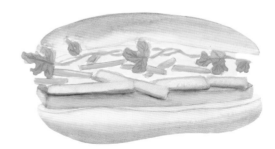

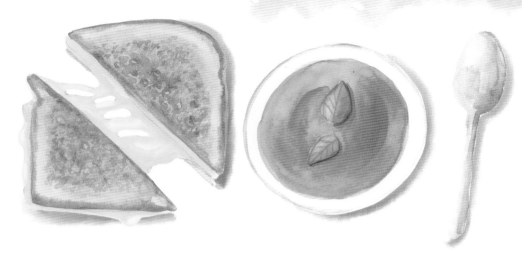

Grilled Cheese and Tomato Soup

Burnt Sienna	Cadmium Yellow Medium	Cobalt Blue	Payne's Gray	Raw Sienna	Sap Green	Yellow Ochre	Cadmium Orange	Cadmium Red Light	tomato soup
							+	=	

I love warm soup on a cold winter day, especially if it's accompanied by a delicious grilled cheese sandwich!

To sketch the grilled cheese sandwich, start with two triangle shapes that are facing each other. The corners will be slightly rounded and in between the two slices there will be a series of wavy lines to show the melted cheese, with some tiny ovals inside.

We'll start with the wet-on-wet technique, covering the bread area of the grilled cheese in a thin layer of water. Next, drop some Yellow Ochre into the wet area and help spread it out using your brush pen. While this is drying, using a similar wet-on-wet technique, add Cadmium Red Light to the tomato soup area.

Now we'll head over to the spoon and paint a thin layer of Payne's Gray (diluted with lots of water so it's light in value) to cover most of the area. Lift off tiny highlights on the left hand side of the spoon. While the spoon is still wet, drop in a little bit of Cobalt Blue as small accents of color and let them spread out.

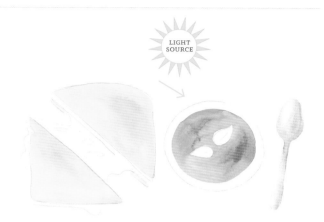

Next, dilute Yellow Ochre with a few drops of water and load lots of this mixture onto your brush to paint another layer on the bread slices. While this is still wet, using Burnt Sienna, add little dots on the bread with the tip of your brush. This will resemble a soft of stippling effect but because we're working wet-on-wet the dots will spread out and become soft, so your quick squiggles and dots will create a nice texture for the toast.

While the paper is drying, mix Cadmium Orange and Cadmium Red Light to get a nice tomato soup color. Paint a layer of this inside the bowl, leaving the left side of the soup a lighter value. You can also lift off just a bit on the left to create a subtle highlight on the soup's surface. The right side should have a deeper value of the tomato color that transitions smoothly into a slightly lighter value on the left.

Then proceed to the spoon. Using a diluted Payne's Gray, add a few shadows on the spoon on the right side and blend those lines in while maintaining a few highlights on the left. Using that same mixture, paint a thin outline of the tomato soup bowl.

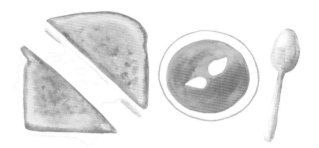

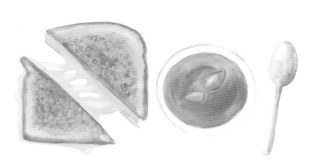

After the painting has dried, take some Burnt Sienna diluted with a bit of water so that it's light in value. Using the very tip of your brush pen and applying very little pressure, add tiny dots all over the bread slices. Also paint some tiny circles to indicate the bread's texture. Continue doing this in a methodic and swift motion. Consider also going over those same dots again with your brush pen to soften them a bit. Though we are working wet-on-dry, we don't want the dots to stand out too much but they should blend into the bread slice to show the texture. Leave the outer areas of the bread untouched so you can see your first layer of Yellow Ochre. After this layer has dried, you can go back with a clean wet brush and soften the dots and circles even more. As you'll notice from the example, these are not perfect dots but rather quick marks from the tip of the brush pen.

For the cheese we'll use Cadmium Yellow Medium. Paint a thin layer of this color over the cheese and save some highlight areas. Keep adding a little more yellow until there is a nice contrast between the highlights on some of the cheese and the rest of it.

For the soup, use a little bit of the mixture of Cadmium Red Light and Cadmium Orange. With the side of your brush pen, and applying pressure, make a large circular mark on the soup. These wider, darker lines will show off the texture of the soup.

After the soup area has dried, use a little Sap Green for the basil leaves. While the leaves are still wet, go back with a clean, damp brush and lift off some tiny highlights.

Use some Cadmium Yellow Medium and add another layer over the cheese to make it really stand out. Be mindful of the highlights, as they will bring your painting to life.

Apply a thin glaze of water over the basil leaves and drop in more Sap Green to deepen the green of the leaves while maintaining the highlighted areas. After the leaves have dried, using Sap Green again, add very thin veins on the leaves to show their texture.

With a little bit of the mixture of orange and red, add a thin line just below the leaves to showcase the shadow they are casting onto the soup in the bowl.

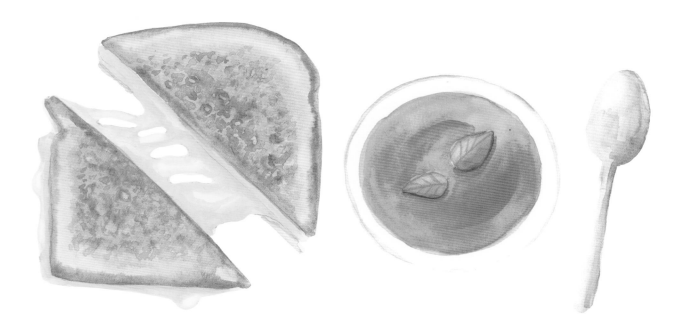

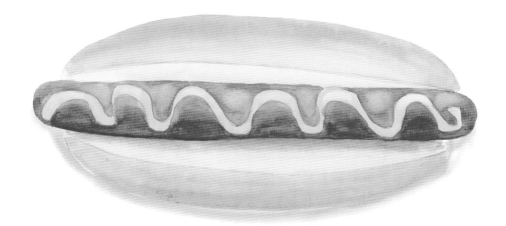

Hot Dog

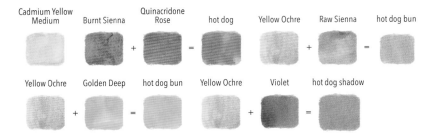

Cadmium Yellow Medium	Burnt Sienna	Quinacridone Rose	hot dog	Yellow Ochre	Raw Sienna	hot dog bun
	+	=			+	=

Yellow Ochre	Golden Deep	hot dog bun	Yellow Ochre	Violet	hot dog shadow
	+	=		+	=

Hot dogs are a quintessential camping food. There's just something magical about a hot dog cooked over a crackling campfire.

To sketch the hot dog, start with two parallel lines that will be joined by a slight curved at each end. The mustard will be a series of two wavy lines inside the hot dog shape. The buns will resemble curved lines that meet towards the hot dog ends.

Our first step is to mix the color for the hot dog using Burnt Sienna and Quinacridone Rose. Paint the hot dog with the wet-on-dry technique, carefully painting around the mustard's wavy lines. As soon as you have painted the whole hot dog shape, while it is still wet, clean off your brush and lift off a few tiny highlights on the left side.

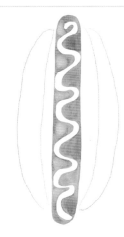

After the hot dog has dried, use more of the hot dog color and paint another layer on the hot dog, on the right side only. The wet-on-dry technique will give you more control in this area since we also need to paint the mustard.

Allow the hot dog area to dry completely and then work on the bun. We'll start by using some Yellow Ochre diluted with water. Using the wet-on-dry technique, apply a layer of this color over the entire shape of the bun.

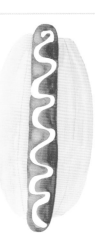

Mix together Raw Sienna and Yellow Ochre to get a deeper bread color and use this mixed color to paint just the outer parts of the bun. While that is drying, use some Cadmium Yellow Medium and paint the wavy line of mustard. Again, we'll be using the wet-on-dry technique so as to retain control. You'll use very little water, and as you're painting the mustard, be mindful of the highlights. We want the highlights to match the hot dog, so they will also be on the left.

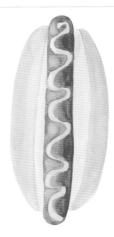

Mix a little bit of Yellow Ochre and Violet to get a grayish-brown color. We'll use this to paint a faint shadow along the right side of the hot dog, inside the bun. After you have painted the shadow, clean off your brush pen and soften the line so the transition is nice and soft.

For the last step, mix together Yellow Ochre and Golden Deep. We'll use this color to add that golden brown accent on the hot dog buns. Paint thin lines along the outer edges of both buns and then soften them using your clean brush pen.

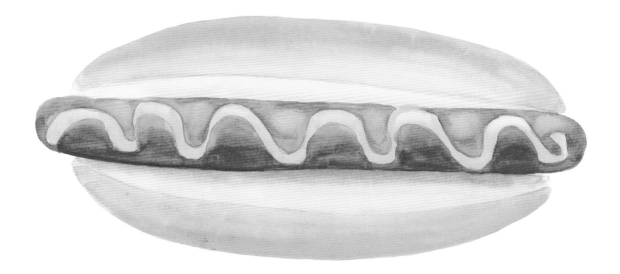

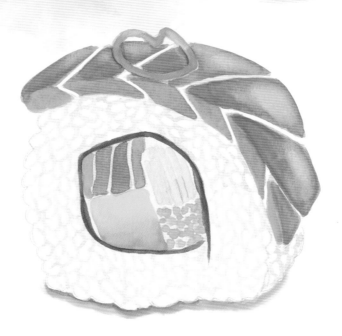

Sushi

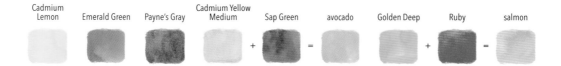

Cadmium Lemon	Emerald Green	Payne's Gray	Cadmium Yellow Medium	Sap Green	avocado	Golden Deep	Ruby	salmon

Sushi is always a good idea! My favorite part is seeing the creativity of sushi chefs in how they prepare the rolls and the technique of assembling them so beautifully.

The sushi roll is essentially composed of two main shapes: the half oval shape of the roll and the salmon sushi slice, which is composed of two parallel curves that come to a point. The rest of the shapes are rectangular pieces for the contents of the roll.

We'll start by mixing Golden Deep and Ruby for a salmon-like color. Add a few drops of water for a diluted value. Using the wet-on-wet technique spread a thin layer of water inside the salmon areas and then drop in the color. Spread it around the shapes, avoiding the white lines of the salmon. The edges of the salmon will be a little lighter in value, which is achieved by adding a little more water to the color mix to make it lighter. Cover the area evenly. Allow the paper to dry before adding the next layer of salmon color.

LIGHT SOURCE

Since the light source is coming from the right at a 45-degree angle, the sushi slice will have some highlights on it. With a clean damp brush, lift off small highlights on the right side. Wipe off the brush after each motion to ensure you are not introducing color back into the shape.

After you've lifted off some highlights, use the same mix of colors for the salmon and paint on a second layer, avoiding the areas of the highlights. Smooth out the colors with your brush so the transition from the highlights to the darker area is smooth.

Paint the salmon piece that is in the center of the sushi the same color (Golden Deep mixed with a little bit of Ruby).

For the avocado slice, start with a layer of Cadmium Lemon Yellow. Cover the area evenly, using less water and more paint. While this yellow layer is still wet, drop in a little bit of Emerald Green at the bottom of the slice. With your brush, blend it in but only halfway, so there is still an area with plain yellow. Blend it by pulling the Emerald Green upward and smooth out the transition between the colors.

Dilute the Emerald Green color until it becomes a very light shade and use this to paint the cucumber slices inside the sushi.

Use Cadmium Orange to paint the carrot parts, which will be tiny circular shapes inside the sushi roll.

Mix Cadmium Lemon Yellow with a little bit of Sap Green to get the color for the jalapeno slice on top of the sushi. Paint this in and lift off some tiny highlights to match the highlights on the salmon.

Dilute some Payne's Gray with just a bit of water and paint the nori (i.e., the seaweed sheet), which is the line around the center ingredients of the sushi roll.

Using the same Payne's Gray, dilute it with a lot of water so the shade of gray is very light and barely visible. This will be the color for the rice. Paint the rice, one by one, in the shapes of ovals and circles, varying directions.

Mix Emerald Green with a little bit of the salmon color to get a neutral brownish color. Use this to add tiny shadows next to the jalapeno slice.

Optional step: Use Payne's Gray diluted with water to add a shadow at the bottom of the sushi roll.

Chapter Three

Snacks

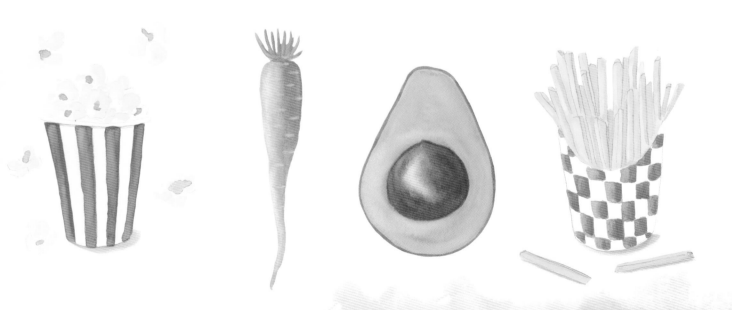

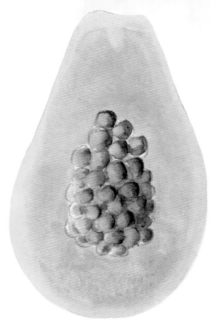

Papaya

Payne's Gray	Cadmium Yellow Medium		Cadmium Red Light		papaya orange
		+		=	

Snacks are what keep me going. Snacks are there to give us a boost. Snacks are there to sustain us. When in doubt, grab a snack. Before we get to the more indulgent snacks, let's learn how to paint some healthy ones!

To sketch the papaya, start with a half circle at the bottom and instead of sketching a circle, extend the lines to meet at the top. Sketch tiny circles inside the shape to represent the seeds.

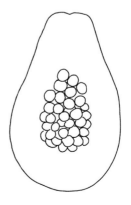

For the papaya, we will start with Cadmium Yellow Medium. Using the wet-on-wet technique, add a layer of water on the papaya, around the seeds. Then, drop in some Cadmium Yellow Medium to outline the papaya shape and also paint some around the seeds. The color will bleed into the wet area, but that's ok, because we will paint over it in our next step.

Next, mix Cadmium Yellow Medium with Cadmium Red Light to get a nice and rich orange. While your yellow layer is still wet, use this orange color to fill in the papaya. If you go over the initial yellow lines from the previous step, you can use more Cadmium Yellow Medium and reinforce those so we see a nice transition from the yellow skin to the orange flesh of the papaya.

Allow the painting to dry. For the seeds, use Payne's Gray, all the while lifting off tiny highlights on their left sides.

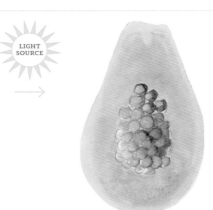

LIGHT SOURCE

For the final step, use a bit of the Payne's Gray—and with just the tip of your brush pen—add tiny brush strokes on the right sides of the seeds to make them really pop.

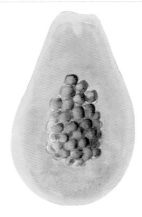

Watermelon

Quinacridone
Rose

Sap Green

Watermelons will always remind me of growing up in Moldova. I fondly remember shopping for watermelons as my dad and I would gently tap them to see which one would be the most ripe.

To sketch a watermelon slice sketch half an oval and connect the line ends with a flat line.

Start by spreading a thin layer of water, covering only the watermelon flesh, not the rind just yet. Drop Quinacridone Rose in the wet area for the wet-on-wet technique. The left side will have a highlight so lift off some of the color from there and drop even more of the color on the right side to make it vibrant.

LIGHT
SOURCE

Allow the watermelon flesh area to dry. Next, using Sap Green, we'll paint the rind with the wet-on-dry technique. Paint a thin line of green along the outer edge, using very little pressure on your brush pen. After the first go, clean off the brush and go over the green stroke applying pressure on the brush pen to soften the line. This step might cause some of the watermelon color to bleed into the rind, but it's ok because you can remove it with a clean brush, lifting off the color to leave a smooth transition from green to white to magenta.

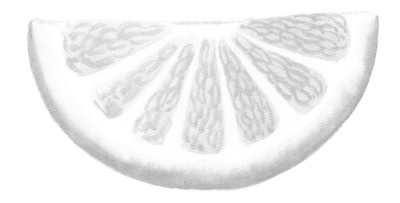

Orange Slice

Cadmium Orange + Cadmium Yellow Medium = rich orange

Oranges are packed with vitamin C and I love to snack on them! Here is a simple way to paint them.

To sketch an orange slice, draw a half circle shape and connect the edges with a flat line. The pulp shapes will resemble elongated and rounded triangles.

Mix Cadmium Orange with Cadmium Yellow Medium to get a nice rich orange color. With the wet-on-dry technique, add a thin layer into each of the triangular sections. Leave white, unpainted space between them.

Then, using Cadmium Orange, paint the rind of the orange slice. With a clean and wet brush pen, go over the same line to soften it with the tip of your brush.

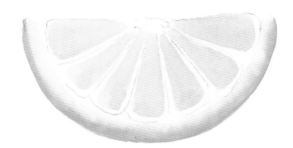

The final step is to use a little bit of Cadmium Orange on your brush pen and paint tiny oval shapes to show the texture of the orange slice. These ovals will be irregular and only slightly darker than the previous layer, but they will still be visible.

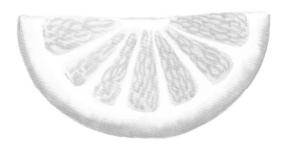

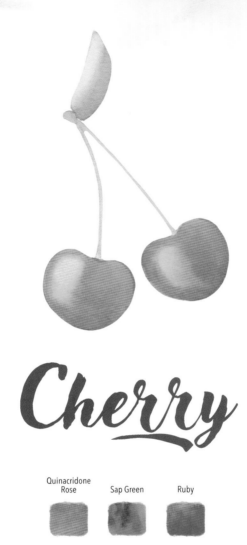

Cherry

Quinacridone
Rose Sap Green Ruby

Cherries are the perfect summer snack!

Spending summers at my grandmother's meant that I'd get to pick cherries. We'd also end up making cherry preserves for the winter, and if you haven't tried, I highly recommend it.

To sketch the cherry, start with a circle and draw a wavy line at the top as if drawing a heart. The leaf will be two curved lines coming together at a point.

Grab some Quinacridone Rose and dilute it with water for your first layer on the cherries, painting wet-on-dry. Paint the cherries with your brush pen, leaving some space for highlights on the left side. You can also lift off some color so the highlights have a smooth transition. While it's still wet, drop in a little more of the color to make the cherries stand out.

Use Sap Green to paint the stems and the leaf, leave a highlight on the left side, and then add a bit more of the green color on the right side while it's still wet.

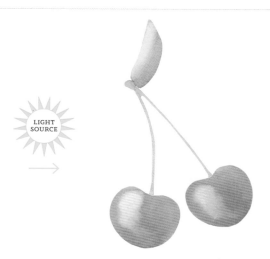

After the cherries have dried, using the glazing method, use the Ruby color to paint another layer over the cherries. This will give them more dimension and will make the cherry color more interesting.

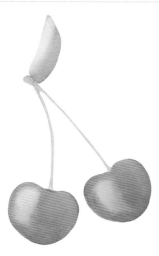

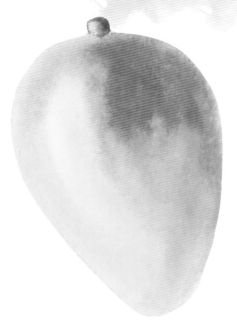

Mango

Cadmium Yellow Medium

Cadmium Red Light

Burnt Sienna

I once heard sharing a mango with someone is the best way to break the ice. It's also super delicious!

To sketch a mango, start with a semi-circular shape at the top, and instead of drawing a circle, extend the lines to come to a point at the bottom.

We'll be using the wet-on-wet technique for the mango painting. Spread a layer of water over the mango and then drop in Cadmium Yellow Medium. Lift off a highlight on the left side with your clean wet brush. Drop in a bit more yellow before proceeding to the next step.

While the mango is still wet, drop in Cadmium Red Light on the right side and spread it around just a bit with your brush pen. The colors will mingle together and will create soft transitions of reds, oranges, and yellows. Have fun here!

Use a little bit of Burnt Sienna to paint the stem at the top, remembering to add a highlight on the left side of the stem.

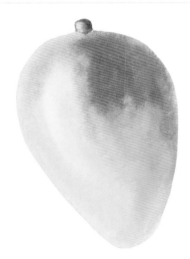

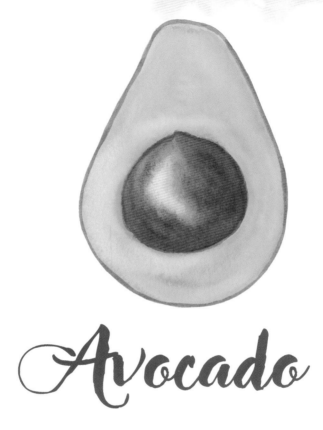

Avocado

| Cadmium Yellow Medium | Sap Green | Raw Sienna | Burnt Sienna |

Avocados are one of those snacks that make me super happy. They're so bright and cheerful and full of joy! And they are versatile too. Did you know avocados are full of healthy fats and can help reduce cholesterol? Avocados are also mood and energy boosters. What a great snack all around!

To sketch the avocado, start with a semi-circle at the bottom and extend the lines upwords to come to a point. The seed will be a circular shape.

To start, we'll use our Cadmium Yellow Medium. This lighter yellow will make our avocado shine like the star of the snack kingdom that it is. Using the wet-on-dry technique, load up your brush pen and paint the Cadmium Yellow Medium over the avocado, leaving the pit area dry. While the yellow is still wet, drop in Sap Green and spread it around like a glaze. If the color looks too green, add a bit more of the Cadmium Yellow Medium. We want a vibrant type of avocado green for this.

After your green has completely dried, add a layer of Raw Sienna for the avocado pit. Spread it around and lift off a highlight. While this area is still wet, drop in Burnt Sienna and spread it around, keeping the highlight present.

While the pit is drying, use the Sap Green, and with just the tip of your brush pen, add a thin outline around the perimeter of the avocado to depict the skin.

LIGHT
SOURCE

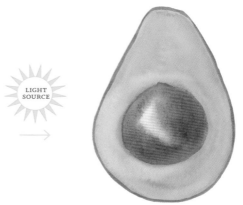

For the final step, after everything has dried, add another layer of glaze on the pit with Burnt Sienna to really make it pop.

Cadmium Yellow Medium Cadmium Orange Sap Green

I love going to the local farmer's market and seeing all the beautiful, colorful varieties of carrots. A great and healthy snack as well as fun to paint.

To sketch the carrot, start two vertical lines that will be joined at the bottom, making the shape wider at the top and more narrow at the bottom. The carrot leaves are a series of irregular lines.

Start with a layer of Cadmium Yellow Medium and cover the whole carrot shape. While it is still wet, drop in some Cadmium Orange. Spread the orange mostly on the right side, leaving a lighter side on the left for the highlight.

After your paint has dried, add a glaze layer of water and lift off more of the highlight on the left side. While it's still wet, drop in a little bit of Cadmium Red Light just at the top of the carrot and mostly on the right. Clean off your water brush pen and then use it to spread the red and smooth it out on the carrot, dragging a little bit of the color downward along the length of the shape.

Use Sap Green to paint the green carrot stems.

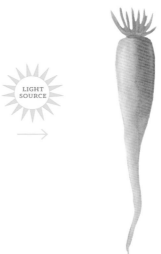

For the final step, with a clean damp brush pen, lift off tiny lines to show some texture on the carrot. For this you'll use the tip of the brush and wipe it off each time you lift off some of the color to create tiny highlights.

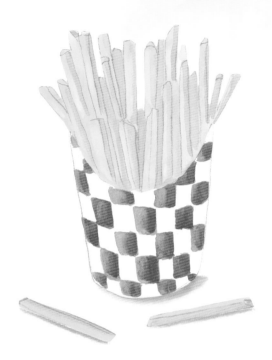

French Fries

Cadmium
Red Light

Cadmium Yellow
Medium

Yellow Ochre

When I first moved to America, French fries quickly became one of my favorite fast foods. Nothing compares to that salty, crunchy bite from a perfect pack of fries.

To sketch the French fry box, start with two parallel lines and a curve that connects them at the bottom. The line at the top of the box will have a deeper downward facing line. The fries are a series of two parallel lines with a little triangle at the top connecting them.

Start with Cadmium Yellow Medium and dilute it with a little water on the palette. Use this to cover the area of the French fries entirely. As you're painting the area, lift off a few small highlights on the left sides of some of the fries.

While this area is drying, grab your Cadmium Red Light and paint the paper container. You could switch it up and paint the whole container in one solid color or create another fun pattern of your choice.

After the paint has completely dried, use a little of Yellow Ochre to paint the shadows on some of the fries. The shadow will be on the right sides since we have highlights on the left. Also, paint over some of the fries in the back of the container in Yellow Ochre to make front fries stand out a little more and to add dimension to the painting.

Finally, you can add another layer of Cadmium Red Light to the container pattern. Add this layer on the right side again, so it matches the shadows on the fries.

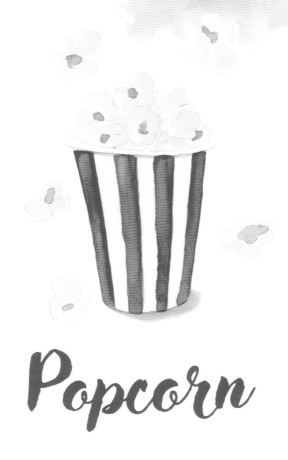

Popcorn

Raw Sienna	Ruby	Cadmium Yellow Medium	Yellow Ochre	popcorn
		+	=	

If you leave out the butter, popcorn can be a really great low-calorie snack option. My favorite part is hearing the kernels pop in the microwave and getting ready to enjoy this snack.

To sketch the popcorn box, start with two lines that are slightly pointing inwards. The lines will be joined by a curve at the bottom and at the top. The popcorn shapes are a series of wobbly lines, almost petal shapes that are joined in the center by another irregular shape.

For the popcorn, we'll start by painting the dark centers of the individual kernels. Dilute a little bit of Raw Sienna on the palette. Then drop this color into the centers of the popcorn kernels. While those tiny areas are still wet, drop in a little bit of Cadmium Yellow Medium for a nice color variation.

While the centers areas are drying, use some Ruby to paint the container.

After your popcorn centers are completely dry, mix some Yellow Ochre with Cadmium Yellow Medium and add several droplets of water so the value is very light. This will be the color for the popcorn. This part is fun because there's no right or wrong way of doing it. Using the new color mix, lightly paint squiggly and random lines, leaving some areas white on each of the popcorn kernels.

Paint another layer of Ruby on the popcorn container.

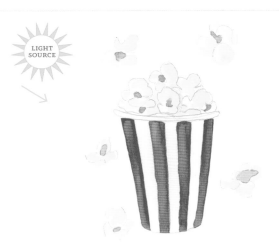

For the last step, use a bit of Payne's Gray to add some shadows. Your color will be diluted with water so it is very light. The first shadow will go below the lip of the container. The other shadow will go below the container. With a clean, wet brush pen, soften the bottom shadow so it has a nice transition.

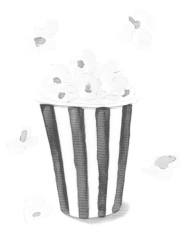

Samosas

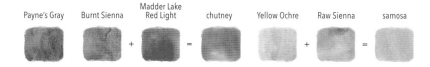

Payne's Gray	Burnt Sienna	Madder Lake Red Light	chutney	Yellow Ochre	Raw Sienna	samosa

Samosas are a fun and delicious baked pastry filled with savory filling, and they are just as fun to paint! We'll be painting Indian-style samosas, which are typically served with chutney.

To sketch the samosas, start with the samosa tray. This will be a rectangle with rounded corners. The chutney dish will be a series of two circles and the samosas themselves are triangle shapes.

We'll start by diluting Yellow Ochre with water on our palette. With a clean brush, add a layer of water for the wet-on-wet effect for the samosas. Once you have the layer of water ready, drop in Yellow Ochre on the samosas area. Make sure to lift a small highlight on the left side of each samosa with a clean, wet brush pen.

While that is drying, mix together Madder Lake Red Light with Burnt Sienna. We'll use this color to paint the small bowl of chutney next to the samosas. Add a layer of the chutney red and lift off a small highlight on the left side to match the samosas.

To get a golden-brown layer of color, we'll mix Yellow Ochre and Raw Sienna on the palette. Add a few drops of water from your brush pen to get a light value of the color. Paint a light glaze on top of the samosas (wet-on-dry), keeping the highlights intact. If you get a little color on the area of the highlight, remove it with a clean brush pen.

Next, using our chutney color mix from the earlier step, paint a second layer of color in the bowl, keeping the highlight intact. You can also drop in more color on the right side so there is some variation in value.

For the bowl, take a little bit of Payne's Gray and dilute it with a lot of water on your palette so the value is really light. Use this color to paint a thin narrow line to showcase the edge of bowl. Making sure your chutney color is completely dry, also use this gray to paint a thin line around the chutney.

After everything has dried, add a layer of Payne's Gray for the tray. To stay in line with our other highlights, we'll use a saturated mix of Payne's Gray on the right and a lighter value of the gray on the left. To get the lighter value, just add a bit more water to the color on your palette. Using a very light Payne's Gray, also add tiny lines on the bowl's edges to give the impression of glass.

To add some shadows on the samosas, use just a little bit of Raw Sienna and dilute it with a few drops of water. Using this color paint very thin lines with the tip of your brush pen on the edges of the samosa shapes so it looks like they are stacked one on top of another and thus casting a shadow. We'll also use this color to add tiny accents on the samosas to show a little bit of the layers of dough. As you're painting these shadows, you can clean off your brush pen and go back to smooth them out to soften and blend the transition.

Using your Payne's Gray, add narrow lines on the tray just to the right of the samosas for the shadows they cast onto the tray.

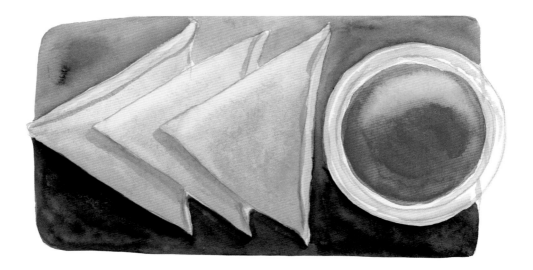

Chapter Four

Dinner

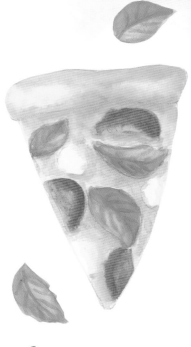

Pizza

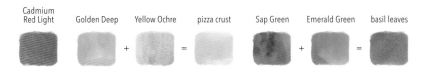

Cadmium Red Light	Golden Deep	Yellow Ochre	pizza crust	Sap Green	Emerald Green	basil leaves

Pizza is probably an all-time favorite for most people! The best part about a pizza is the sheer number of toppings and combinations you can create for a delicious slice of pizza pie.

To sketch the pizza slice, start with a triangle shape. Then build up the crust by drawing a wide and wobbly rectangular shape at the top. The tomatoes are half circles, the mozzarella cheese bits are circular, and the basil leaves are a series of curves that come to a point at both ends.

Using the wet-on-wet technique, spread a thin layer of water over the pizza slice, leaving the basil and the mozzarella areas dry. Load some Yellow Ochre on your brush and drop some of the color onto the wet area. The yellow will spread to create a soft first layer of color. Allow the paper to dry completely.

Mix Yellow Ochre and Golden Deep to get a warm, light value of orange, which we'll use to add golden-brown accents to the pizza crust. Apply a thin layer of this mixed color on the crust, keeping some areas uncovered for the highlights. The highlights on the crust should be irregular to give the impression of the baked crust. While the area is still wet, drop some Golden Deep and Yellow Ochre mix in a few areas, where the crust meets the pizza slice to show a darker value there.

Also, over the entire pizza slice, add a few brush strokes of the Yellow Ochre/Golden Deep mix here and there to add some texture. Remember, as you're adding these brush strokes, you can blend them into the rest of the shape for a smooth transition.

Next, grab your Cadmium Red Light and paint over the tomato slices. Because the previous layer might still be a little wet, some of the Cadmium Red Light might bleed into the pizza slice, but this will create a nice effect showing how the tomatoes are transformed after being baked on the pizza. Add another layer of red on the tomato wedges to make them a little darker in value.

Next, mix together some Emerald Green and Sap Green to get a nice green for our basil leaves.

Paint the leaves with this green, lifting off a few highlights as you go.

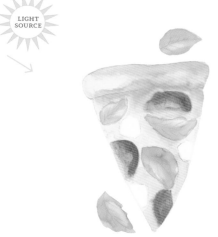

LIGHT SOURCE

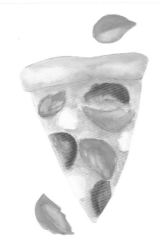

Using the side of a clean wet brush pen, smooth out the areas around the mozzarella slices. This technique will cover the mozzarella slices with a little bit of the color from outside those areas and will create the melted look of the cheese.

Using a little bit of Sap Green and Emerald Green mix paint another layer on the basil leaves, leaving off the highlights.

Using your diluted Yellow Ochre, go over the pizza slice and add tiny, irregular brush strokes to showcase the texture of the pizza dough. And as you do this, grab the mixture of Golden Deep and Yellow Ochre and add thin brush strokes on the toppings to introduce small shadows. You can add another layer of Golden Deep and Yellow Ochre mix on the pizza crust to give it a darker value for that golden brown and delicious look.

Add another layer of Cadmium Red Light on the tomato slice skins to make those stand out a little more.

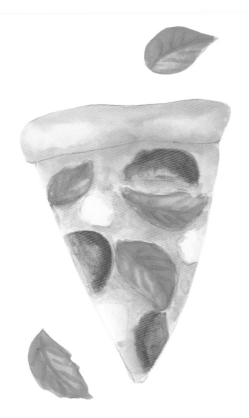

Our final step is to make the basil leaves a little more pronounced. Add another layer of Sap Green and Emerald Green (being mindful to save the highlights), and as the area is still wet, paint the leaf's veins with Emerald Green. These brushstrokes will be soft with this wet-on-wet technique and will add dimension to the painting.

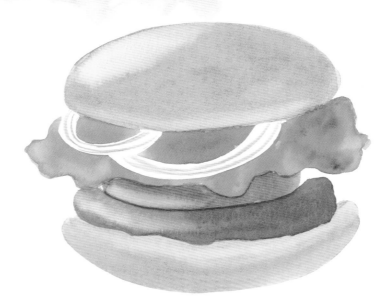

Burger

Burnt Umber	Cadmium Red Light	Raw Sienna	Sap Green	Ultramarine Violet	Yellow Ochre

One of my earliest memories as an immigrant in the U.S. is having burgers with my parents. We'd get in a car and find the nearest restaurant to enjoy some delicious and juicy burgers. Nowadays I enjoy them with a vegetarian patty.

To sketch the burger buns, start with an oval-like shape at the top. Next sketch out a few curves to represent the onion rings and for the lettuce draw a wobbly line. A few more curves will follow to show the tomato and beef patty. The bottom bun can be drawn as a curved shape that has rounded corners.

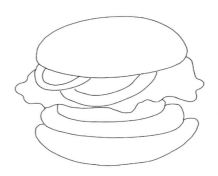

For the burger painting, we'll start with the buns using the wet-on-wet technique. First, apply a thin layer of water over the buns. Then use Yellow Ochre diluted with a few drops of water to paint over the wet areas. Our highlight will be on top-left part, so as soon as you paint that area, go back in with a clean, wet brush pen and lift off a highlight there, while the area is still wet.

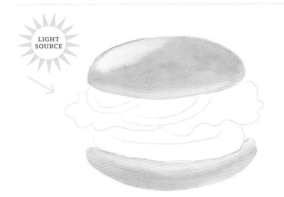

Next, dilute Raw Sienna with a few drops of water. Use this to glaze over the buns, keeping the highlight intact. While this layer is still wet, lift off a little bit of color from the inside edges of the buns to create a nice contrast between light and dark values on the buns. Allow the paper to dry completely.

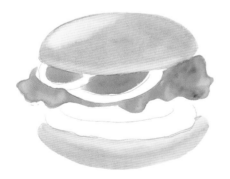

Next, apply a layer of water on the lettuce area. While it is wet, drop in Sap Green to cover the area. Use more pigment and less water in some areas to show some darker values for the folds of the lettuce leaf, so it isn't a uniform color value. Allow the paint to dry again before the next step.

Dilute Cadmium Red Light with a bit of water and paint wet-on-dry over the tomato slice. Lift off a small highlight on the left side.

Next, dilute some Burnt Umber with water and use this to cover the burger patty. Again, lift off a small highlight on the left to match the tomato and the bun.

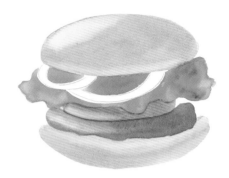

Finally, use Ultramarine Violet diluted with water to add tiny lines on the onion rings. These will be very light in value. Use this same color to add tiny shadows below the burger patty as well.

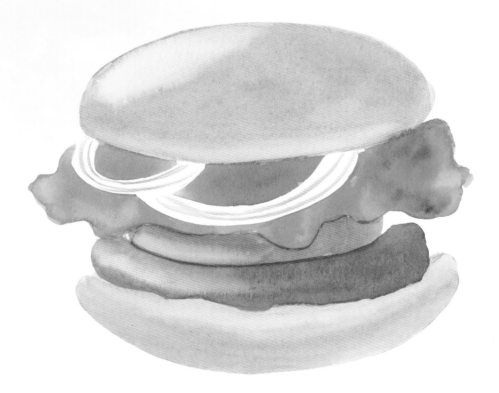

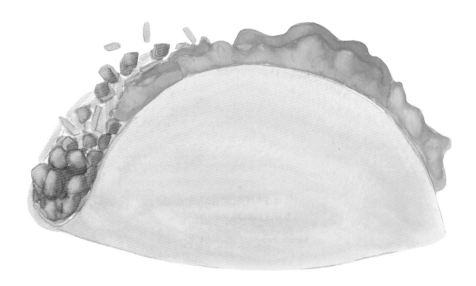

Taco

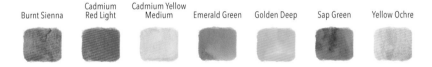

| Burnt Sienna | Cadmium Red Light | Cadmium Yellow Medium | Emerald Green | Golden Deep | Sap Green | Yellow Ochre |

Tacos are one of my favorite food groups! There's no limit to the variety of toppings and combinations of ingredients for a taco. Talking over some delicious tacos is one of my favorite pastimes.

To sketch the taco, start with a semi-circle shape, and then instead of drawing a circle, draw a flat line that connects the ends. The lettuce leaves will be a series of wavy lines, while the tomato pieces will be tiny cube shapes and the meat will be tiny ovals. The cheese pieces will resemble tiny rectangular lines.

For this taco painting, we'll start with the wet-on-wet technique. Apply a layer of water over the taco shell and then drop in Yellow Ochre, spreading the color over the entire area. While it is still wet, drop in some Cadmium Yellow Medium, mostly toward the middle and bottom of the shell, and spread it out evenly while blending the colors together. Allow this to dry.

With the wet-on-dry technique, apply diluted Sap Green on the lettuce leaves (on both the front and the back leaves). While it is still wet, drop in a bit of Emerald Green on the backmost lettuce leaves so the front leaves are a warmer value from the Sap Green alone. As soon as you have done this, clean off the brush pen and lift off a few highlights on the front lettuce leaves. These highlights will create the appearance of folds on the leaves. Allow the paper to dry again.

Next, we'll proceed to the rest of the taco filling. We'll use very little water for each of these because we want to retain control over all the small details. With some Golden Deep, paint the cheese bits. Then use Cadmium Red Light to paint the cube-like tomato shapes. Add a bit more red pigment on one side and leave a tiny highlight where possible. Next, use Burnt Sienna to paint the beef bits. Again, lift off some highlights on those pieces for a more dimensional look.

Fill in the gaps between the fillings with Yellow Ochre and use it to once again outline the taco shell in the back.

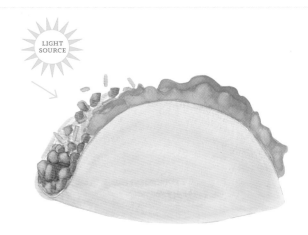

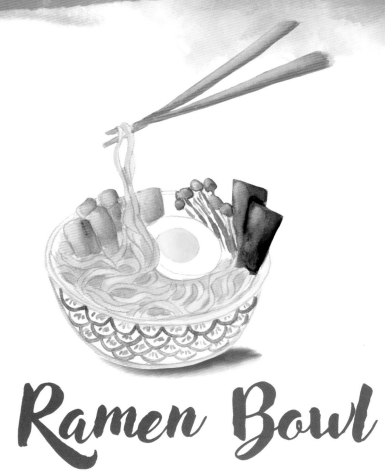

Ramen Bowl

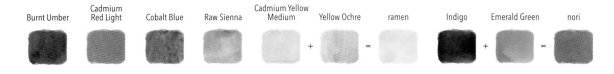

| Burnt Umber | Cadmium Red Light | Cobalt Blue | Raw Sienna | Cadmium Yellow Medium | Yellow Ochre | ramen | Indigo | Emerald Green | nori |

I love a warm bowl of ramen on a rainy day. It's the perfect hug for your heart and soul (and stomach) to lift your spirits.

To sketch the ramen bowl start with a circular shape and then draw a crescent moon curve below it, extending the shape to meet the circle. Sketch the noodles as a series of long and wavy lines. The egg will resemble an oval shape with a circle inside. Sketch the meat and nori sheets as rectangles and the mushrooms will be a series of triangles on top of thin lines.

We'll start by diluting Yellow Ochre with several drop-lets of water to create a nice light value. Use this to paint the noodles and the tofu slices on the left. While the area is still a little wet, use some diluted Cadmium Yellow Medium and outline some of the noodles. The Yellow Ochre and Cadmium Yellow Medium will natu-rally mix together to create varying values of yellow on the noodles.

Dilute Raw Sienna with a few drops of water and use it to paint over the tofu slices. Add more pigment on the right side of each piece, leaving small highlights on the left.

While that is drying, we can work on the nori sheets. Mix together Indigo and Emerald Green making sure to get a nice even color. This mix should be dark in value so use just a few drops of water. Paint the area of the nori sheets and, as soon as you have covered them, go back with a clean, damp brush pen and lift off highlights on the left. Next, using just the Indigo from the palette, outline the left side of the nori sheet in the foreground so it looks like it's casting a shadow on the nori sheet behind it.

LIGHT
SOURCE

Using Cadmium Yellow Medium paint the yolk of the egg and then lift off a highlight on the left side.

Next, use some Burnt Umber and dilute it with just a bit of water. Paint over the mushrooms and immediately lift off tiny highlights on the left sides of mushroom heads.

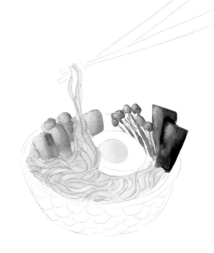

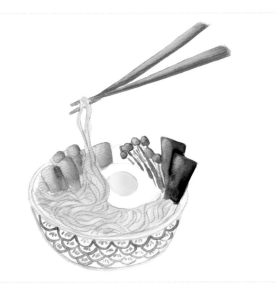

Dilute some Cadmium Red Light with just a few drops of water so the value will be pretty dark and then apply this on the chopsticks. While the chopsticks are still wet, lift off highlights across the top of each stick.

Use diluted Cobalt Blue to paint the scalloped pattern on the bowl. Feel free to experiment with your own designs and patterns. Lightly outline the shape of the bowl in a lighter value of Cobalt Blue.

Finally, using Yellow Ochre mixed with a little bit of Cadmium Yellow Medium; paint the small areas between the noodles to create shadows, which will add more depth to the painting. These shadows should be randomly distributed, leaving some of the noodles unpainted to differentiate between the noodles toward the back (darker) and the noodles toward the front (lighter). Using this same color, add a tiny shadow below the egg.

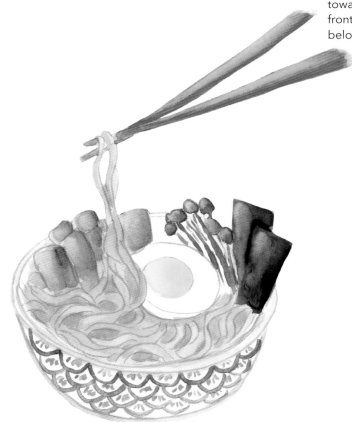

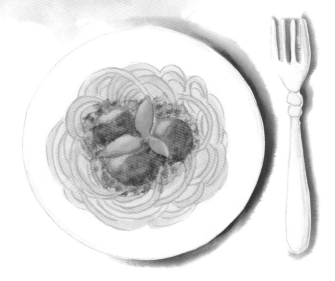

Spaghetti and Meatballs

Burnt Sienna	Cadmium Red Light	Cadmium Yellow Medium	Payne's Gray	Raw Sienna	Yellow Ochre

Noodles of any kind are really comforting, and a classic way to boost your mood with some carbs is spaghetti and meatballs.

To sketch the plate draw a circle. The meatballs will also be circles and the basil leaves are going to resemble tear drops. The spaghetti will be a series of double-lined curves that will intersect with each other. To draw the fork, sketch a very narrow tear drop shape with two circles on top. The fork teeth will be a series of wavy lines going up and down and extending towards the circles.

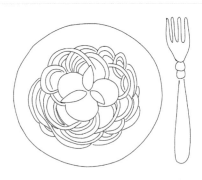

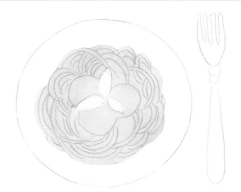

We'll start this painting by diluting Yellow Ochre with a bit of water to achieve a medium value of the color. Using the wet-on-dry technique, use this to cover the area of the noodles and the meatballs (leaving the basil leaves untouched).

Allow the first layer to dry. Next, dilute Cadmium Yellow Medium with water to get a fairly light value. Use this to paint over some of the noodle strands. The color will create some dimension between the lighter Yellow Ochre and darker Cadmium Yellow Medium. Allow the paper to dry completely.

Next, dilute some Raw Sienna with just a bit of water, as we want the color to be fairly saturated and dark in value. Paint over the meatballs. While the area is still wet, drop in some Burnt Sienna straight out of the well and mostly on the right side, leaving small areas for highlights on the left. Lift the highlights with a clean damp brush pen to increase the contrast between the dark and light values on the meatballs.

For our tomato sauce, dilute a little bit of Cadmium Red Light with water and clean off the brush pen. Using a damp brush pen spread a light layer of water over the area of the meatballs so the paper is just a little bit wet. Then, using the diluted Cadmium Red Light, add tiny dots with the brush pen tip. This will resemble the stippling technique where there is a series of small, quick dots. Because the area was wet prior to adding the dots, some of them will dissolve into the meatball and blend with the colors underneath. Use the same technique to add some red dots to the area surrounding the meatballs, and then clean off the brush pen. With the clean damp brush pen, go over those same dots. This will allow the dots to blend into each other and to also blend into some of the noodle area. The result should give the impression of tomato sauce that varies in value from light to dark.

Next, grab some Sap Green and paint over the basil leaves. Lift off tiny highlights on the left sides to match the meatballs.

Finally, dilute some Payne's Gray with lots of water on your palette. The value will be very light and barely visible on the paper. Use this to add tiny shadows on the fork (on the right side) and to outline the plate.

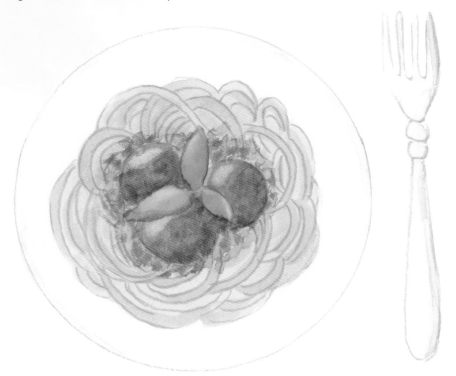

Chapter Five

Desserts

Macarons

Quinacridone
Red Cerulean Blue macaron

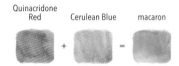

+ =

Macarons are delicate cookie delights that can always boost your mood.

We'll keep this project fairly simple and use just two colors from the palette, and we'll mix these two colors together to get a third for our macarons. An optional additional color is Payne's Gray if you'd like to use it to add a cast shadow.

To sketch the macarons, start with a slender oval shape a the top. The macaron skirt will be a wavy line. The bottom shell of the macaron will be flatter, but still slightly curved.

Starting with the wet-on-wet technique, apply a layer of water on the top macaron shell. Using Quinacridone Red, drop some color into the wet area. Keep in mind that we want our highlights to really stand out, so save a small area on the left side for the highlight. Because of the wet-on-wet technique, the transition from more color on the right fading into the highlight on the left will be very smooth. Allow your first macaron to dry before proceeding to the next one.

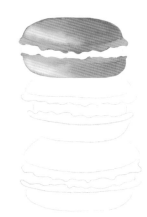

Mix together Quinacridone Red and Cerulean Blue to get a nice purple color. Similar to the steps above, paint the middle macaron using the wet-on-wet technique. Drop in the purple while saving the highlight on the left. Allow to dry completely.

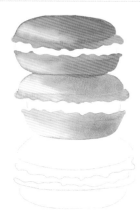

Paint the third macaron using Cerulean Blue, again using the wet-on-wet technique.

Now we will add some shading on the macarons to make them appear more vibrant. After your last color has dried, use the same colors for each respective macaron, painting just a small layer of color on the right side of each of the shells. Then, wipe off your brush pen and drag the color that you just added to incorporate it, smoothing it into the rest of the shape.

For the macaron skirts use a saturated color mix (i.e., more pigment with less water) to make them a darker value. This will add the appearance of shadows on those parts.

Finally, add a shadow using the wet-on-wet technique. Apply water right below the bottom macaron and then drop in a little bit of Payne's Gray for a quick cast shadow.

Cake

Cadmium Red Light	Cobalt Blue	Quinacridone Red	Yellow Ochre

Cake is always a good idea. This strawberry cake is super fun to paint.

To sketch the cake slice, start with a rectangle. Then draw a triangle shape sitting on top. The edge with the icing will be a series of wobbly lines. The icing will also drip over as a wavy line. Sketch the strawberries as a series of curves, and the cherry as a circular shape with a line for the stem.

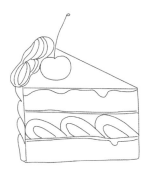

We'll start with the wet-on-wet technique by applying a thin layer of water onto the icing parts of the cake. Then, dilute some Quinacridone Red with a lot of water on your palette. The result should be a very light value that looks more like pastel pink than red. Drop some of this color into the icing parts of the cake. Allow this layer to dry.

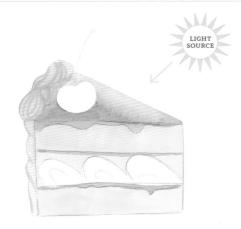

Now, dilute some Yellow Ochre with a few drops of water. Use this light value of Yellow Ochre to paint the cake parts using wet-on-dry technique.

After the yellow cake area has dried, load your brush pen with the diluted Quinacridone Red from your palette and add a second layer on the icing. The direction of light is coming from the top right, so save the top-left area for the highlight. If you see harsh brushstrokes, use a clean wet brush pen to smooth them out into the rest of the shape. You should have a smooth transition from the highlight into the darker values of Quinacridone Red. Paint the strips of icing between the layers of cake. Also, use this color to outline some of the folds in the icing. Allow the paint to dry completely.

Next, we'll work on the strawberries using the wet-on-wet technique. Spread a thin layer of water over the strawberries. Dilute Cadmium Red Light with a few drops of water and drop it into the wet area. Make sure the middle parts of the sliced strawberries remain unpainted. This technique will give a soft glow to the strawberry slices. With the tip of your brush pen, keep adding Cadmium Red Light, little by little, focusing mostly on the edges.

Use the same diluted Cadmium Red Light from your palette to paint the cherry and its stem, using the wet-on-dry technique. Keep in mind that the highlight will be on the top right to match the icing.

Using a little bit of Cobalt Blue, paint a very thin line right below the cherry, on the bottom left. Then, with a clean, wet brush pen, smooth the blue out over the icing. This will create a small cast shadow below the cherry.

You can also add more diluted Quinacridone Red and outline the icing folds once more for added contrast.

Finally, after everything has dried, add another layer of diluted Yellow Ochre on the cake areas, glazing to add more contrast.

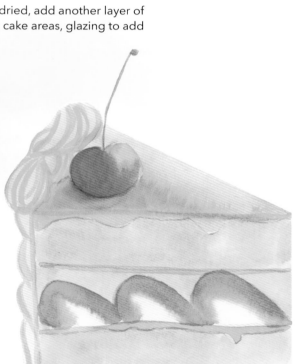

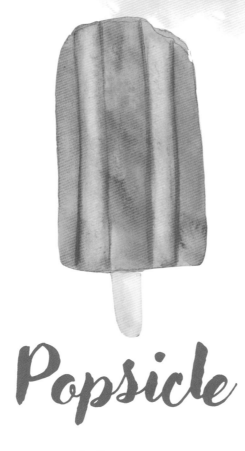

Yellow Ochre	Quinacridone Red		Golden Deep		popsicles
		+		=	

I love painting popsicles. They come in all kinds of fun colors and they lend themselves super well for watercolor painting due to their melting properties.

To sketch the Popsicle start with two parallel lines and a flat line at the bottom, connecting them. The line at the top will be more of a curve with a slight edge to show the bite part of the Popsicle. Sketch the stick as two parallel lines with a curve at the bottom.

We'll start with the wet-on-wet technique. Spread a thin layer of water over the popsicle. Then load your water brush pen with Golden Deep and paint a few random strokes into the wet area. While this is still wet, using Quinacridone Red, similarly add some random brush strokes around the shape. Clean off the brushpen and then use it to help the colors mingle together. Allow your paper to dry completely.

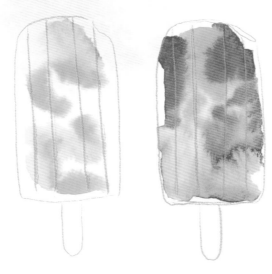

With a clean wet brush pen, use the entirety of the brush and apply a lot of pressure to lift off highlights from top to bottom, creating the two ridges on the popsicle. You won't lift off the color entirely, but just enough to make it lighter in value than the rest of the area.

Mix Golden Deep with Quinacridone Red and dilute it with water for a light value. Use this to paint a second layer of color on the popsicle (avoiding the highlights that you just lifted off).

Using the same color mix but in a slightly darker value (so less water and more pigment), use the tip of the brush pen and apply very little pressure to paint thin vertical lines along the ridges so those areas stand out.

Finally, use Yellow Ochre to paint the popsicle stick, lifting off a small highlight on the right side.

LIGHT SOURCE

Donut

Quinacridone Red Raw Sienna Yellow Ochre

Donuts are another fun treat to paint because they are basically wobbly circles, which is great because it relieves the pressure of trying to make it look perfect.

To sketch the donut start with a circular shape with a slight curve to the side to show the bite mark. The dough part will follow as a curve just below the main icing shape. Sketch two circular shapes inside to represent the donut hole.

We'll use the wet-on-wet technique for this painting. Start with a thin layer of water and cover the icing part of the donut. Then, load up your brush pen with Quinacridone Red: this will be supersaturated, so less water and more pigment. Paint with the Quinacridone Red on the edges of the icing shape, leaving the middle parts unpainted.

Because the paper is wet, the paint will bleed, so with a clean brush pen, lift off any excess paint to allow the highlight to remain visible. While the area is still wet, you can drop in a little more Quinacridone Red along the edges of the shape to make them more vibrant and pronounced. The highlight here will be in the middle of the icing as it circles around the shape of the doughnut. Allow the paint to dry.

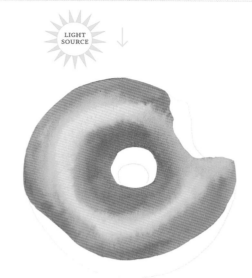

Dilute some Yellow Ochre with water to achieve a light value. Using the wet-on-dry technique, paint the cake parts of the doughnut. While it's still wet, use Raw Sienna to paint very thin lines on the edges of the cake areas. This will create some variation in values on the cake, making the doughnut appear more interesting.

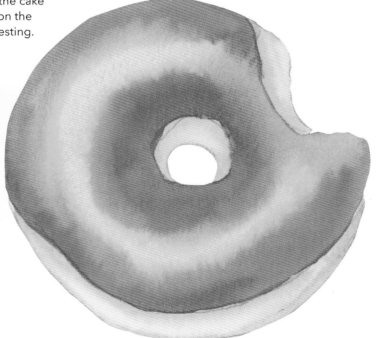

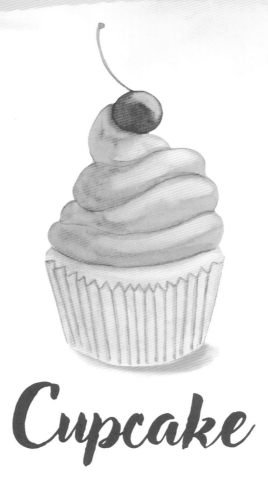

Cupcake

Quinacridone Red | Raw Sienna | Ruby | Yellow Ochre

Cupcakes were another dessert that I discovered upon moving to the U.S. It was an instant fascination because of the single serving size that can be decorated in a unique and colorful way.

To sketch the cupcake, start with two almost parallel lines for the wrapper. Connect the lines with a curve at the bottom and a zigzag line at the top. Draw out lines for the ridges on the cupcake wrapper. The icing will be a series of uneven curved lines to represent the folds. The cherry is a circle with a line for the stem.

For the cupcake we'll start with the wet-on-dry technique. Grab your Quinacridone Red and dilute it with a lot of water. The result should be a puddle of water with a little bit of pigment so the value of the wash will be light, like the pink icing on the cake slice we painted earlier. Cover the icing area with a layer of this color, and while it's still wet, clean off the brush pen and lift off some highlights on the right side. Lift off a few times and clean the brush pen repeatedly. Allow the pink icing to dry before the next step.

For the cherry, dilute a little bit of Ruby with water and cover the cherry area. Immediately lift off a highlight on the right side to match the icing's highlights.

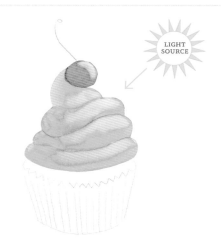

Using the same diluted Quinacridone Red from your palette, add a second layer on the icing with the wet-on-dry technique, keeping in mind to leave the highlights unpainted. Most of this second layer will be on the left side and also in the recesses of the layers of icing. If you notice hard lines from this layer, soften them with a clean damp brush pen so the transitions between dark and light values appear smooth.

Add a second layer of Ruby on the cherry with wet-on-dry, remembering to save the highlight. Allow the paint to dry completely.

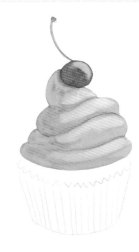

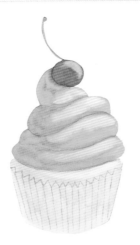

Dilute some Yellow Ochre with water. Using the wet-on-dry technique, paint a layer of this color over the cake area as well as over the wrapper. While this is still wet, use a clean, wet brush pen and lift off a small highlight on the top-right part of the cake.

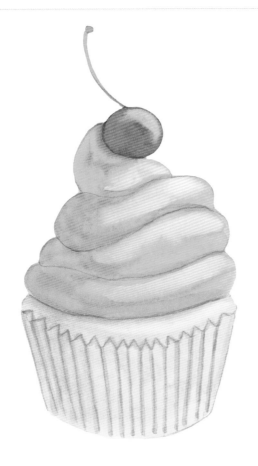

For the final steps, add some details to the wrapper. Dilute a bit of Raw Sienna with a few drops of water and use this to paint lines for the ridges. Using the tip of the brush pen while applying very little pressure will give you control to paint these narrow lines. As you get closer to the left side of the wrapper, apply a little more paint, making it darker in value to match the darker value of the icing on top. Use the tip of the brushpen to add a tiny shadow on the cake just below the icing.

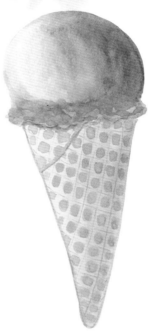

Ice Cream Cone

Raw Sienna

Ultramarine Violet

Yellow Ochre

Ube (pronounced ooh-beh) is as sweet purple yam that makes for a delicious ice cream flavor. It's popular in the Filipino culture and it's oh so fun to paint… and to eat!

To sketch the ice cream start with a circular shape for the scoop at the top. Then draw a flat line connecting the curve and a wavy line right below it. The cone will resemble a triangle shape with a rounded corner and a series of intersecting lines to show the cone texture.

We'll start with the wet-on-wet technique. Dilute Ultramarine Violet with a bit of water. Squeeze one drop of water from your brush pen and spread the water over area of the ice cream scoop. Next, load your brush with Ultramarine Violet and start dropping it into the wet area. Our highlight will be on the left side, so as soon as you paint over the area, lift off the highlight with a clean wet brush (and continue to lift off until there is a nice, smooth highlight). While the paper is still wet, drop in a little more Ultramarine Violet on the right side to increase the contrast between the highlight and the shaded side. Do the same on the area where the scoop meets the skirt (the wavy lines at the bottom of the scoop). Adding more pigment there will create a nice shadow. Allow to dry completely.

Use some Yellow Ochre and paint the cone with the wet-on-dry technique. While the cone is still wet, drop in a bit of Raw Sienna on the right side to create a darker value for the shaded side, which will match the ice cream scoop. Allow this area to dry completely.

Next, dilute a bit of Raw Sienna with a few drops of water to create a dark value. Painting wet-on-dry, use this to paint the small irregular square-like shapes depicting the cone's texture. Paint these carefully inside the grid of pencil lines.

Finally, use more Ultramarine Violet on your brush pen and add narrow, squiggly lines along the skirt of the ice cream scoop. This second layer will create some areas of a darker value against the lighter background, thus adding more interest to the ice cream scoop. Also add a second layer of Ultramarine Violet to slightly darken the right side of the scoop, and then pull that paint into the rest of the shape, maintaining the highlight.

Chapter Six

Drinks

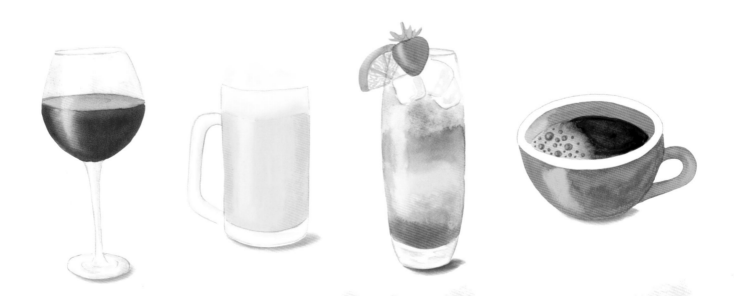

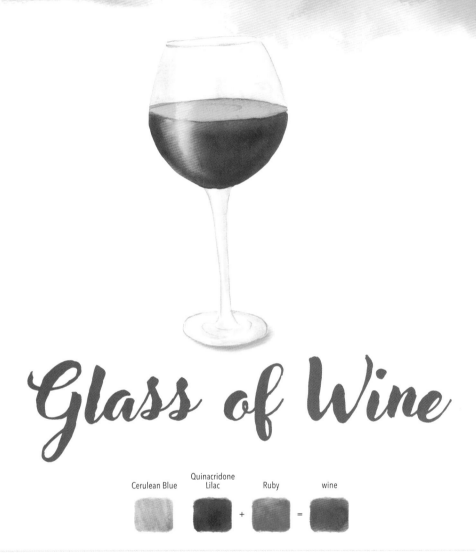

Glass of Wine

Cerulean Blue Quinacridone Lilac Ruby wine

Moldova's rich tradition in wine-making goes back thousands of years and a fun fact is that it also has the largest wine cellar in the world.

To sketch the shape of the glass start with a curve and extend both sides upwards so that it's a bit more narrow. Connect the lines at the top with a slightly curved line and then sketch a mirror line next to it. Sketch a thin oval inside the glass to show the wine. The stem of the glass will be two parallel lines with an oval shaped base.

For this painting, dilute some Ruby with a little water to get a dark, saturated value of the color. Using the wet-on-dry technique, paint the wine area—but leave the top surface of the wine blank. While it's still wet, drop in some Quinacridone Lilac and spread it around inside the shape. Work quickly so the area doesn't dry, and then with a clean, wet brush pen, lift off a highlight near the left side of the glass. The result of mixing these colors together on the paper will give a variation in values of reds and purple (or lilac in this case) and will create a lovely wine-like color. Allow the paper to dry.

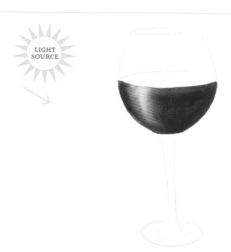
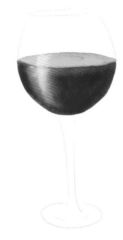

Next, mix Ruby and Quinacridone Lilac on your palette and add a few drops of water to create a light value. Use this to paint the top surface of the wine, wet-on-dry. While this is still wet, use a clean wet brush pen to lift off a small highlight. The highlight will continue on from the highlight on the wine below.

After the paint has dried, we'll move on to painting the glass. Dilute Cerulean Blue with water so you have a very light value. Using this color, paint the glass, being mindful of the highlighted areas. On the stem, most of the Cerulean Blue will cover the right side since our highlights are on the left. Similarly, on the bowl of the glass (above the wine) there should be a slight high-light that continues from the wine area. Finally, add a few strokes on the base of the glass, softening them as you go.

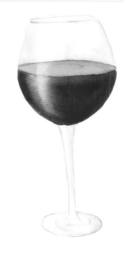

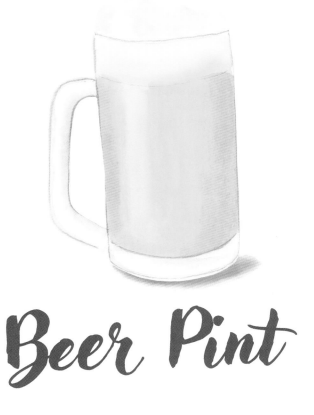

Beer Pint

Cadmium Yellow Medium Cerulean Blue Yellow Ochre

Next time you're at a happy hour outing with friends, grab your watercolor sketchbook with you. Beer glasses make for fun and easy watercolor paintings.

To sketch the beer glass, start with two parallel lines and a curve that connects them at the bottom. Draw another curve parallel to that as well as two more curves at the top of the glass. The beer foam will be a wavy line and the beer handle will be two parallel lines that connect with the glass at a curve.

This beer painting is fairly simple. We'll start with wet-on-wet, applying a thin layer of water over the beer area so the paper glistens, and then drop in Cadmium Yellow Medium. Spread the color with your brush pen to cover the entire area of beer. Then with a clean, wet brush pen lift off a highlight on the left. Similarly, with your clean wet brush pen, soften the top line of the beer to create a subtle transition where the beer meets with the foam. Wetting the paper with just a wet brush pen will allow some of that Cadmium Yellow Medium to seep through for a more dimensional and fun painting. Allow your paint to dry.

Next, using the wet-on-dry technique, apply another layer of Cadmium Yellow Medium on the beer area. Be mindful of the highlight and keep that area unpainted. Since we are working wet-on-dry, this layer might create hard edges around the highlight. You can soften these edges with a clean wet brush pen by going over them and lifting off the hard edges (using the entire side of the brush pen and applying pressure). While the layer is still wet, apply a little bit of Yellow Ochre along both sides of the glass. This will add interest to the color of the beer.

Add a thin layer of water on the foam part and drop in diluted Yellow Ochre here and there. This will give the foam a little more dimension instead of looking flat.

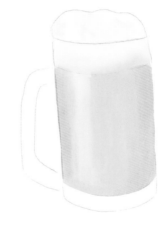

Finally, dilute Cerulean Blue with water to achieve a light value and use it to paint the glass areas. The highlight on the glass handle will be on the left to match the highlight on the beer. Soften your brushstrokes with a clean brush pen.

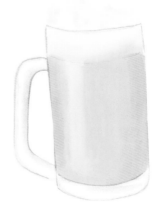

Boba Tea

Indigo	Payne's Gray	Quinacridone Red	Ultramarine Violet

I love a refreshing boba tea! The tapioca pearls create a fun and exciting delight when enjoying this beverage.

To sketch the boba cup, start with two lines that are slightly pointing towards each other. Connect them with a curve at the top and at the bottom. The plastic lid will be a semi circle shape and the straw will be two parellel lines joined by a tiny oval shape.

We'll start with Ultramarine Violet and dilute it with a few drops of water on the palette. Using the wet-on-wet technique, use a clean brush pen to wet the entire area of the liquid, covering the boba pearls as well. Drop in the Ultramarine Violet and spread it over the wet area. Drop a little more pigment on the left side, and while the area is still wet, with a clean, damp brush pen, lift off a highlight on the right side. Allow the paper to dry completely.

Dilute a little Indigo on your palette with just a bit of water. We want this to be a dark value so the boba pearls really stand out. Paint each of the pearls, wet-on-dry, and as soon as you finish, with a clean, damp brush pen, lift off a tiny highlight in the shape of a crescent moon on the right side of each pearl.

For the drinking straw, we'll use diluted Quinacridone Red. Mix several drops of water with the pigment to make a very light value. Use the wet-on-dry technique to apply this to the straw. Keeping in line with the rest of the painting, lift off a highlight along the right side of the straw.

Allow your paint to dry and then paint a second layer of Indigo on the boba pearls, but just on the left sides, to add even more contrast between the dark and light values.

For the last step, dilute a little Payne's Gray with a few drops of water so you get a very light value of the color, barely visible. With the wet-on-dry technique, use this to outline the clear plastic lid. Smooth out these lines with a clean, damp brush pen. Outline the little ridges at the bottom of the cover as well. Paint a line of gray just below the lid (right on top of the Ultramarine Violet) and soften it at the bottom to give the impression of a cast shadow.

Cup of Coffee

| Burnt Umber | Quinacridone Red | Yellow Ochre |

There's nothing better than a warm cup of coffee to start your day, if you're a coffee lover, like me. Coincidentally, coffee is also a lot of fun to paint.

To sketch the coffee cup start with two curves that create a crescent moon shape. Then draw an oval on top of that, followed by a smaller oval inside with a series of small and large circles. The handle will be a curved line that connects to the cup.

Start with Quinacridone Red diluted it with several droplets of water on the palette. You want a very saturated color, so add more Quinacridone Red pigment if need be. Use this to paint the coffee cup using the wet-on-dry technique. As you're covering the area, lift off a few highlights on the left side. Remember to add a small highlight on the inside-left part of the cup as well. Similarly, there should be a small highlight on the handle that follows along its shape. Allow the paper to dry completely.

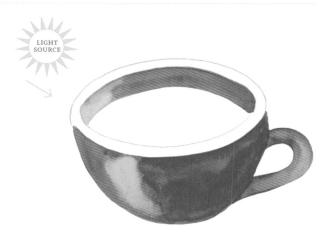

Dilute some Yellow Ochre with a few drops of water. Use this to cover the area of the coffee, wet-on-dry. While the coffee area is still wet, take some Burnt Sienna directly from the well for a concentrated value and drop it in to cover about half the coffee area. The colors will mix together and will create a nice contrast between the Burnt Sienna and Yellow Ochre. With a clean damp brush, soften the edge so the Burnt Sienna blends smoothly into the Yellow Ochre, showcasing the foam of the coffee.

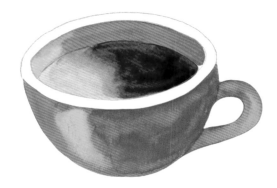

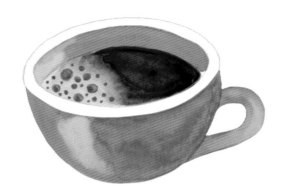

Dilute Burnt Umber on the palette with just a few drops of water. Your mix should be fairly dark in value. Use this to add a second, darker layer on the right side of coffee. Again, use a clean, damp brush to soften any hard edges. Allow everything to dry before moving on to the next step.

Add a few more drops of water to the Burnt Umber on your palette to make it a little lighter value. Use it on the tip of the brush pen to paint circles of varying sizes on the light area of coffee. These will be the coffee bubbles. Allow to dry completely.

Finally, with a clean, damp brush pen, lift off tiny high-lights on the bubbles, each on the left side.

Optional step: if you'd like to add some coffee beans to your painting, paint those with wet-on-dry technique using Burnt Umber. Allow to dry and add a thin narrow line in the middle of the coffee bean shape using the same Burnt Umber.

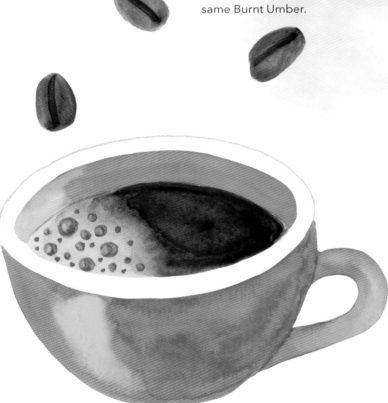

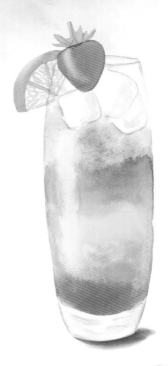

Rainbow Cocktail

Cadmium Orange	Cadmium Red Light	Cadmium Yellow Medium	Cerulean Blue	Sap Green

I love pretty cocktails. The more colorful, the better. I chose this Rainbow Pride-inspired cocktail because it has so many colors and it's so fun to paint.

To sketch the cocktail glass start with two slightly curved lines that are mirroring each other and are joined by a two curves at the bottom. Draw another curve for the orange slice, a rounded triangle for the strawberry and squares for the ice.

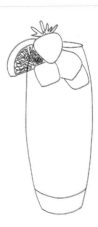

We'll start by adding a few drops of water on the sketch, inside the cocktail area. Spread the water over the whole area so the paper glistens.

We'll need to work fairly fast so the paper doesn't dry out on us. If it does, you can always add a bit of water and spread it out.

We'll work with the paints straight out of their wells so the colors are vibrant and the values are dark.

On your wet area, start by dropping in some Cadmium Red Light at the bottom of the glass. Then above the Cadmium Red Light, drop in some Cadmium Orange. Above the Cadmium Orange, drop in some Cadmium Lemon. Above the yellow, drop in some Sap Green and then drop in Cerulean Blue above the green.

Because we have a layer of water on the paper, these colors will mingle together naturally. You can even add one drop of water where two colors meet to encourage them to blend together even more.

As soon as you have all your colors applied, lift off highlights on the left side. Be sure to clean the brush pen after every single lift, because we don't want to get the colors mixed in with each other when we're lifting off that area.

Mix together Quinacridone Red and Cadmium Red Light. Use a saturated value of this mix to paint the strawberry at the top. Lift off a highlight on the left with a clean damp brush pen.

Next, dilute a little bit of Cadmium Orange with water in your palette. Use this light value to paint tiny ovals to represent the pulp of the orange slice.

Next, add a little more Cadmium Orange pigment on your palette to get a darker value of the color. Use this to paint the orange rind and then lift off a small highlight across the rind.

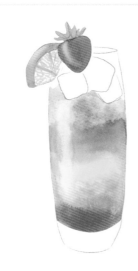

Finally, dilute Cerulean Blue with a lot of water to get a very light value of the color. Use this to paint the ice cubes and also for some areas of the glass. For the ice cubes, outline them with color and then add a few random brushstrokes on the right sides of the cubes. These will be fairly abstract strokes just to give the impression of a shadow and to add dimension to the cubes. Use a similar approach to the bottom portion of the glass, adding a few brushstrokes in light Cerulean Blue.

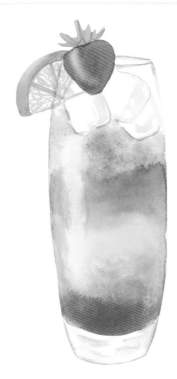

Acknowledgements

From the bottom of my heart, I would like to thank the team at Rocky Nook for believing in me and seeing the potential for a book on my favorite subject—watercolor foods! This new-to-me endeavor quickly became the most fulfilling project I've ever done and for that I am grateful beyond words.

I would also like to thank and acknowledge my incredible parents without whose sacrifice I would not even be in this country and have access to opportunities that I have.

I also want to thank my husband Dan, my sweet mother-in-law Patrizia, my brother Julian, and sweet friends like Gerald, who have always encouraged and supported my artistic journey, even when it seemed impractical to do so. To my mentors and teachers, to my collaborators and supporters, and to all the strong women I've met since I started this journey, thank you for your endless support and for inspiring me to step into my own power.

And to all the students I have met through my in-person and virtual workshops, an eternal thank-you from the bottom of my heart and soul. The greatest gift for me has been the honor to be someone who encourages you to live with a little more creativity in your life, one painting at a time.

About the Author

Originally from Moldova, Volta is the founder of Color Snack and her mission to watercolor the world can be seen in the various projects such as brand activations, custom illustrations, and animated GIFs that she creates for national and international brands (like the Dallas Mavericks and Pernod Ricard). She has taught thousands of students in her online and in-person watercolor workshops, where she encourages everyone to discover their inner artist.

Volta has been featured in *D Magazine,* Dallas Morning News, Dallas Observer, Create Magazine, and others. She is frequently interviewed on the topics of creativity, entrepreneurship, and mindset.

Volta is the creator of Watercolor Meditations, a concept and online class that combines breathing exercises with watercolor techniques for a calming and relaxing experience.

Volta's podcast Art, Snacks + Affirmations is a space where she helps artists and creative entrepreneurs to build a resilient mindset. She also is a co-host to a live Instagram show (Watercolor Happy Hour) where she and her husband Dan share cocktail recipes and then teach how to paint them.

Connect with Volta:
https://www.instagram.com/colorsnack/
https://www.colorsnack.com/

Watercolor Supplies:

Here's a list of a few of my favorite shops where I purchase watercolor supplies frequently.

https://www.dickblick.com/

https://www.jerrysartarama.com/

https://www.cheapjoes.com/

https://www.michaels.com

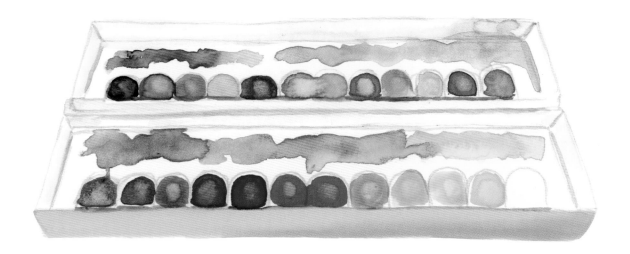

Index